LUCIEN PISSARRO IN ENGLAND

THE ERAGNY PRESS
1895–1914

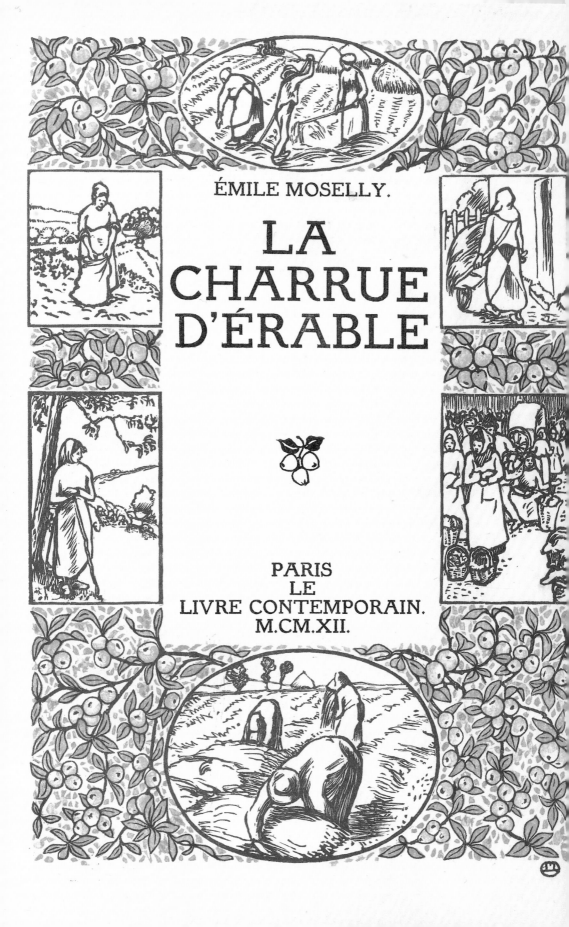

ÉMILE MOSELLY.

LA CHARRUE D'ÉRABLE

PARIS
LE
LIVRE CONTEMPORAIN.
M.CM.XII.

LUCIEN PISSARRO IN ENGLAND

The Eragny Press
1895–1914

OXFORD
ASHMOLEAN
MMXI

Copyright © Ashmolean Museum,
University of Oxford 2011

First published in the United Kingdom by the
Ashmolean Museum, Publications Department,
Beaumont Street, Oxford OX1 2PH

ISBN 978-1-85444-253-6

British Library Cataloguing in Publication Data
A catalogue record for this book is available
from the British Library

Catalogue designed by Dalrymple
Typeset in Adobe Jenson
Printed & bound in the UK by EPC Direct Ltd

For further details about the Ashmolean
Museum's publications please visit:www.
ashmolean.org/shop

Frontispiece: Émile Moselly, *La Charrue d'érable*,
Paris, Le Livre contemporain, 1913 [cat.47a]

ASHMOLEAN

CONTENTS

PREFACE ❧

Thanks to esther pissarro, lucien pissarro's widow, and to other members of her family, the Ashmolean is now one of the most important places in existence for the study of French Impressionism. The museum has over fifty paintings by various Pissarros, many thousands of prints and drawings and countless letters, including 850 by Camille Pissarro, the founder of this remarkable dynasty of artists. The collection is chiefly famous as a source of information about Camille and his Impressionist colleagues, but by far the largest part of the archive concerns the life and work of Camille's eldest son, Lucien, founder of the Eragny Press. The Ashmolean has held many exhibitions over the years dealing with different members of the Pissarro family but this is the first which has been devoted to Lucien's books. This is perhaps surprising but books are not easy to exhibit and can normally be seen in exhibitions only two pages at a time. We have tried to overcome this problem by including several copies of the more important books in order to give the visitor a better idea of the artistry hidden inside these little volumes. We could not have done this without generous loans from two private lenders to whom we give our heartfelt thanks. We are also grateful to our colleagues in the Bodleian for agreeing to further loans and for preparing them for exhibition, to Christopher Lloyd and Colin Franklin for their practical and welcome support, to Agnes Valenčak, Head of Exhibitions, to Graeme

Campbell and the Ashmolean Design Office, to David Gowers and the staff of the Photography Studio, to Stella Ditschkowski and Lara Daniels in the Paper Conservation Studio and to Anne Thorold whose invaluable work in putting the Pissarro Archive into immaculate order is familiar to all who have used it. We are also indebted to Lelia and David Stern of the Stern Pissarro Gallery and to the Paul Mellon Centre for Studies in British Art for making generous contributions towards the costs of the catalogue and to Simon Shorvon, who wrote the charming account of life at Brook House for the catalogue. Dr Shorvon has helped throughout in the preparation of this exhibition and, along with Lelia and David Stern, is the latest in a line of benefactors from the families of Esther and Lucien who have supported the Pissarro Collection since Esther's first gift in 1950. Our chief thanks, however, must go to Victor Benjamin, who first suggested this exhibition to the Ashmolean and has acted as external curator from first to last. He has been an invaluable support and the ideal colleague. Finally, we gratefully acknowledge Richard Green's generosity in lending us *The Cricket Match* by Camille Pissarro. This painting, which has not been seen in public since 1912, aptly sums up the theme of this exhibition, the *Entente Cordiale* between English and French art which gave the work of Lucien Pissarro its unique character.

CHRISTOPHER BROWN *Director*

INTRODUCTION ❧

I N SEPTEMBER 1947, THREE YEARS AFTER THE DEATH OF Lucien Pissarro, his widow Esther and her nephew, John Bensusan-Butt, cast the punches for making type for the Eragny Press into the middle of the English Channel. She did this according to the wishes of her husband with whom she had managed the press for eighteen years. The gesture symbolised the place, somewhere between France and England, which the Eragny Press had occupied in the revival of hand-made books at the end of the nineteenth century.

Lucien Pissarro, eldest son of the Impressionist painter Camille Pissarro, was born in France in 1863 but lived for more than half his life in England. He settled here in 1890, married an Englishwoman and became an English citizen in 1916 but never forgot his French upbringing nor the Impressionist painters whom he had known since childhood. He was devoted to his father and to his father's art and turned to him constantly for advice and assistance long after he had settled in London. The letters which passed between them, published by Janine Bailly-Herzberg and Anne Thorold, are extensive, tender and deeply felt. It is this which must have made Camille's repeated criticism of Lucien's borrowing from English Pre-Raphaelitism very wounding to his son. He had found, in the circle of Charles Ricketts and his friends in London, a philosophy of art which he believed could be grafted onto the ideas of the Impressionists and a degree of practical support and encouragement which he had never experienced in France. 'Don't forget', Lucien wrote to his father, 'that we – the young generation – we are going to be in a no-man's land – our education is emphatically Impressionist but, at the same time, we have learnt a great deal in the oppo-site camp. In any case the two schools are not irrevocable enemies and we are attempting, on the contrary, to bring then together, or at least to create another art which, I hope, will be the art of tomorrow.' There were several areas where the two could co-exist in an *entente cordiale*: the anarchism of Camille and Lucien combined easily with the Socialism of William Morris and the Arts and Crafts movement. The French symbolist writers who were friends of Camille and published by Lucien found an echo in the work of Ricketts and his colleagues. Ricketts also admired Camille's art and although he did not, himself, imitate the work of the Impressionists, an increasing number of young English artists at the beginning of the new century were taking inspiration from their work. Camille, however, did not reciprocate. Despite Lucien's attempts to explain the principles of the

Detail of the binding paper with a printed pattern of winter aconites for *Les petits vieux* by Emile Verhaeren [cat. 27c].

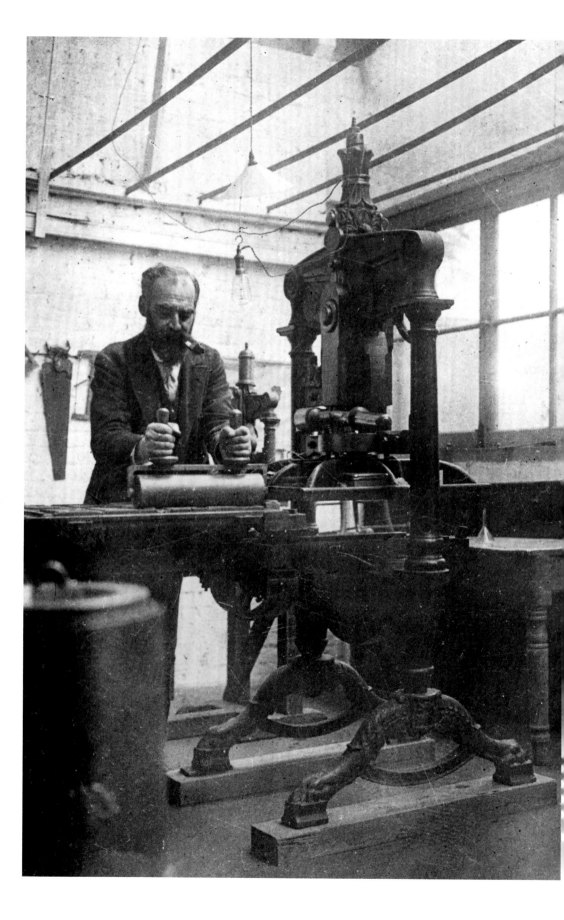

new English art to his father, Camille deplored his son's experiments in a style which he felt was fundamentally opposed to Impressionism. Lucien protested but he had too great a respect for his father's opinions to reject them out of hand. He was, also, all too aware that his press was only kept afloat by gifts of money which his father could ill-afford. As a consequence, several of the books in the early years of the press are marked by Lucien's attempt to follow the advice of his father and return to his origins but without abandoning the principles of the English Arts and Crafts movement. The result is a delicate synthesis of styles combined with a mastery of colour printing which the rival presses never tried to imitate.

Lucien did not have the capital resources which underpinned most of the other private presses of the 1890s and all his books were made in the face of constant hardship. Esther played a major part, not only in cutting woodblocks but also in managing much of the business side which Lucien disliked. The watermark in the pages and the press mark in the books which combine their initials acknowledge the role which both played in the production of the books. It is a heroic tale of devotion to an art which brought them little profit and much trouble. When they had printed their last book in 1914, Lucien turned to painting which he had never abandoned during the years of the press but which now became the mainstay of his life. He was a fine painter with a distinctive style and played an important role in English art between the wars but it is to his books that he owes his special place in the history of art.

♣ I. LES PRINCESSES AU POMMIER DOUX.

ER RIER' chez mon pé re,

6

THE ART OF THE ERAGNY PRESS ✿

JON WHITELEY

L UCIEN PISSARRO WAS NOT DESTINED BY HIS PARENTS TO become an artist. His mother, in particular, had hopes of finding him secure employment and it was chiefly at her insistence that he was sent to London in 1883 to learn English and make a living in a trade. During the months he spent in London, he became acquainted with English art and met his future wife, Esther Bensusan, but showed no aptitude for trade and after his return to France in the spring of 1884, he made up his mind to become an artist. His father, Camille, was not unsympathetic to his son's ambition and found him a place in a print workshop directed by his friend Michel Manzi who managed part of Goupil's vast commercial print-making industry. This was uncongenial work, painstakingly adding colour to a lithographic stone, but it introduced Lucien to the rudiments of colour-printing which became his speciality. It was not easy to make money through painting, as Lucien's mother knew only too well, and working as an illustrator and print-maker for books and magazines offered better prospects. Exactly when Lucien began to make his first woodcuts is uncertain but it probably followed his first brief lesson in wood cutting from Auguste Lepère, the leading specialist in wood engraving in France. What is clear is that Lucien took up wood engraving after he came back from England in 1884 and that he was then working under the eye of his father. It was Camille who introduced him to Lepère and it was he who provided his son with several of the drawings which Lucien then cut on wood. Of the first fifteen items in Lucien's catalogue of his wood engravings, eight vigorous and crudely cut prints are after drawings by Camille. At about the same time, late in 1884, Lucien began work on his first book, *Il Etait une bergère* [fig. 1], based on a popular ballad and extensively illustrated in watercolour with images of rural life. He intended to reproduce these in coloured lithographs transferred to stone from relief images on zinc. Two of the prints in Lucien's personal catalogue of his woodcuts (Fern 7 and 11) correspond to two of these illustrations in black outline, prepared for colour, but the project went no further.

Camille had influential friends in the world of writers and publishers and did his best to encourage interest in Lucien's book. The images were carefully prepared from preliminary drawings and have an assurance and charm, combined with an engaging naivety, which were well suited to pictures in a book for children. Lucien was no doubt correct when he

attributed his lack of success not to his inexperience as an artist but to the cost of reproducing his illustrations in colour. He had relatively more success in supplying black and white prints and drawings to several of the recently founded illustrated magazines: *La Vie Moderne, Le Chat Noir, La Revue Illustrée, La Plume* and others [fig. 2]. Several of these were engraved on wood by Lucien himself in a style imitated from the work of Charles Keene and the illustrators who worked for *Punch* [fig. 3]. Lucien owned a large collection of Keene's work, copied a caricature by Keene in one of his early prints and used blank pages from *Punch* for making prints and drawings. This, no doubt, accounts for the air of humour and caricature in many of these early works. Camille briefly experimented with a similar journalistic type of drawing in his series of illustrations, *Turpitudes sociales*,

Fig.1 | Illustration from Lucien's first book, *Il Etait une bergère*, (1884).

Fig.2 | Illustration from *Patron and employée*. Wood engraving, 1887.

Fig.3 | *Punch's Almanack* (1886).

but, in general, his own drawing style was altogether different, more painterly and improvised and ill-suited for transfer to the printing block.

There is very little similarity between the prints which Lucien made after his father's work in the late 1880s and the images, inspired by the work of popular illustrators like Renouard and Keene, which he supplied to the illustrated magazines. The watercolours which Lucien made for *Il Etait une bergère* were drawn in a style which was distinct from either. From the start, the watercolours which he prepared for the book, followed by a number of illustrations for other stories – *L'Histoire d'un long nez, A Trip to Apple's Country, L'aventure en sabot* [cat. 8] and others – are marked by a debt to contemporary English picture books. Walter Crane's illustrations, in particular, with their bright, simple manner, strong outlines and flat colour gave Lucien an indication of how he could escape from the subordination of wood engraving to the drawing. The genius of English wood engraving, exemplified in the illustrations after Millais or Charles Keene, had been used extensively in books and magazines to create facsimiles of pen drawings which were reproduced with illusory virtuosity. Crane's art suggested a way of working that respected the character of the wood. It was an example which was reinforced by Lucien's liking for Japanese woodcuts. He applied these lessons to his prints for the first time in a series of coloured woodcuts made in the late 1880s. Three of these – *Little May, Le Fagot, La Cueille des pommes* – are dated in Lucien's catalogue to 1889 and subsequent prints in the same manner – *April, Enfants jouant, Floréal, Contentment, Premiers Pas, Le Bouquet, Le Tennis, Baigneuse* – are dated 1890 [cat. 10]. The themes of childhood and the simplified style of these prints derive from the watercolours in the illustrated books for children on which he was working at the time and set the pattern for his future work. Lucien's monogram, enclosed within a circle like the stamped characters on Japanese prints, appears for the first time on *Le Fagot*, an indication, perhaps of Lucien's interest in the Japanese woodcuts at this time or, perhaps, in the work of the print-makers, Henri Rivière and Toulouse-Lautrec, who used similar monograms.

In addition to his work as an artist, Crane must also have appealed to the Pissarros as an active supporter of Socialism. The reforming ideals of the Arts and Crafts movement in England to which Crane contributed were familiar to Camille and seem to have inspired him to look for a career for his sons within a similar revival of the applied arts in France. In June 1889, he enrolled Georges, Lucien's younger brother, in Ashbee's Guild and School of Handicraft in London. In November, Lucien followed his brother to England with hopes that his work would find a more favourable reception in the land of William Morris than it had done in France. His earlier failure to find an English publisher for his books should have given him a warning of the difficulties he was to face. London publishers proved as unreceptive as the French and he might well have given up and returned to France, as Georges did in 1890, had he not struck up a friendship with the English artists, Charles Ricketts and Charles Shannon, within a month of his arrival. Ricketts, in particular, spoke French fluently, loved French art and shared Lucien's ambition to publish books illustrated with artistic woodcuts. Ricketts and Shannon were both trained wood engravers and

introduced Lucien to a number of like-minded artists, Thomas Sturge Moore, Reginald Savage, William Rothenstein, Laurence Binyon and others, several of whom played an important part in Lucien's printing career. On 23 November, Lucien wrote an elated letter to his father: 'they share many of our ideas and, curiously, they all practise engraving on wood! … only they are very skilful, having learned the art of engraving.' In reply, Camille gave his son a warning, often repeated over the years, not to undervalue the untutored simplicity of his art which was worth more than imitative work, however skilled. Lucien replied that it was not a question of mere skill but an understanding of the nature of wood. A design, intended for a woodcut, should anticipate the characteristics of the medium. This is what the Old Masters had understood and it was in this respect that one could learn from them, not to imitate what they had done but to follow their principles. It is evident from the woodcuts of 1889–90 that Lucien had reached this conclusion for himself. But Ricketts also taught Lucien the importance of matching the print to the letterpress and harmonizing the whole within a publication which might exist as a work of art in its own right. These ideas were much in the air at the time and crystallized in the formation of William Morris's Kelmscott Press in 1891. Lucien, like others in the Arts and Crafts movement, was deeply impressed by the principles of William Morris which he acknowledged in an essay published in the year of Morris's death. But Lucien's books do not resemble those made by Morris. The colour in Lucien's books, which is one of their chief character-istics, is not found in Kelmscott books nor in any of the private press books produced in England in this period. Lucien's woodcuts are fresh and simple and owe little to the elaborately mannered woodcuts in Morris's books, designed by Burne Jones whose art Lucien dismissed as literary and lacking in artistic feeling. Kelmscott may have been the first of the private presses to produce a book but it was not the model for the enterprises undertaken by Ricketts and Lucien: at least, it was not the direct model although the principles of Morris were undoubtedly the driving force. In December 1890, a year before the appearance of the Kelmscott Press, Lucien told his father that Ricketts wanted to become the 'Morris of the book.' Again, in April 1891, he said that Ricketts's ambition was to do for the book what Morris had done for furniture. But private presses were costly and while Morris could afford the luxury of his own press, Ricketts was less wealthy and had to wait for a backer before setting up as a printer. Lucien, on the other hand, had no means whatsoever, apart from subsidies from his father, and was constantly hampered by lack of capital. Ricketts, meanwhile, worked as a book designer and occasional publisher, providing Lucien with an outlet for his work that he never had previously. In 1893, he published Lucien's woodcuts of 1889–90 in the *First Portfolio* [cat. 10], a series of twelve prints which summarised the evolution of Lucien's art from 1889 until his meeting with Ricketts and Shannon. Ricketts also included a woodcut by Lucien, *Sister of the Wood* in the second issue of his art magazine, *The Dial*, in 1891. Camille did not wholly approve: 'the large woodcut is very skilful, but I find less of you in it, beware of the Pre-Raphaelites, this type is not yours, as is your little woodcut, *The Girl Collecting Faggots*, that is a pearl.'

Lucien denied any debt to the Pre-Raphaelites and suggested that it must have been the girl's floral dress that had given Camille the mistaken idea that he had borrowed from his English contemporaries. Camille replied that the English character of the print was evident in a certain stiffness and solemnity and that it lacked the naive charm of his earlier work. This became a recurrent theme in Camille's letters to his son, in part inspired by the evident debt to English book design in Lucien's work from this time onwards but also, in part, by Camille's preference for the rough, unskilful naivety of the early woodcuts when set against the increasingly competent work produced by Lucien in England.

Given Camille's concerns about the direction of Lucien's art, it is not surprising that Lucien's first book, *The Queen of the Fishes* [cat. 17], published in 1896 by Ricketts and Shannon, gave him immense pleasure. Printed for Lucien at a local press at Epping, it bears many marks of inexperience although the images are neatly cut and charmingly designed. As they had no type, Lucien wrote the text by hand and reproduced it photographically on the page. The nearest comparisons, Blake's *Songs of Innocence* and *Songs of Experience*, were modelled, like Lucien's book, on small, popular books for children. Blake's books, however, although well known within Ricketts's circle and admired by Lucien, are unlikely to have influenced *The Queen of the Fishes*. Nor does it show any of the Pre-Raphaelite influence, so deplored by Camille, but is a continuation of Lucien's book projects of the 1880s, printed in colour and in gold. The floral borders are light and restrained, unlike Morris's elaborate floral borders, and the images have none of the historicism which is a feature of much of the illustration in England produced by Lucien's English friends and contemporaries. The children in Lucien's illustrations are modern children and the landscape has echoes of Eragny. The difference between the work of Ricketts and Lucien is clear from a comparison between *The Queen of the Fishes* and Ricketts's first published book, George Thornley's translation of *Daphnis and Chloe* [cat. 14], designed on the model of the fifteenth-century book, the *Hypnerotomachia Poliphili*, and on the art of Botticelli. Ricketts had no compunction about imitating past art while Lucien had been brought up by his father to be true to himself and to avoid pastiche.

In 1895, Ricketts and Shannon published a portfolio of six prints by Lucien on the theme of the *Travaux des champs* (Rustic Labour) reproducing drawings by Camille [cat. 12]. These prints originated in the years before Lucien had settled in England and are characterised again by his early work in France. They were part of a larger collaborative project, first mentioned by Lucien in 1886, which occupied both artists for the remainder of Camille's life. His approach to the problem of transferring the drawings to the block changed over the years while he worked on the *Travaux*, particularly through the influence of the Japanese woodcuts which both artists had admired at an exhibition in Paris in the spring of 1890. Camille, too, learned to adapt his drawings to the needs of the print, outlining the figures with black contours like leading in stained glass as a pattern for Lucien's key block although Camille never practised wood engraving and did not always understand what Lucien required.

Lucien's second book, *The Book of Ruth & The Book of Esther* [cat. 18], published in 1896, is superficially a different publication from his other work at this time. The Vale type, lent by Ricketts, gives the pages a greater density than the pages of *The Queen of the Fishes* and the four black and white illustrations are darker and more compact than those in the other book. The decorative detail is spare with no border round the illustrations and the printing is crisp and assured. But Camille was disappointed, accusing Lucien once again of having fallen under the spell of Ricketts and Shannon and turned to the Pre-Raphaelites. The accusation is difficult to follow in a literal sense since three of the four illustrations echo his rustic studies while the fourth, the *Coronation of Esther* [cat. 18c], is touched by Lucien's interest in Persian miniatures which Camille himself had recommended as a model of 'primitive' art. The English influence is more pronounced in Lucien's next publication, the first of two volumes of Laforgue's *Moralités légendaires* [cat. 19], in which the debt to Morris and Ricketts is more frank. Camille, however, found it 'very beautiful.' But when volume two was published in 1898, he was more tight-lipped: 'given the nature of the aesthetic idea in which the drawing has been conceived, I have nothing to say, everything that is liable to criticism being wilful, the outline remains which seems to me as good as anything you have already published.' By contrast, Camille was much taken with the frontispiece of Perrault's *Deux contes de ma Mère Loye* [cat. 21] which he found 'entirely to my taste, these woman still belong to a race of giants but yet they are not exaggerated, they are altogether in proportion and carefully drawn,

Fig.4 | *Roses d'antan*

the arms, the hands, the costumes, the poses have a good natural feeling and are full of charm and style.' Camille's enthusiasm for one of Lucien's most Pre-Raphaelite images might seem inconsistent but it is not the only instance of this. Lucien, himself, was struck by his father's enthusiasm for his wood engraving, *Roses d'antan* [fig. 4] published in the French magazine, *Image*, in 1896. 'It is odd that you like the Roses d'Antan, it is, in my opinion, my best wood engraving – but in the manner which I would say was the opposite of the Queen of the Fishes, all my efforts since then have tended towards that – you seem to judge my wood cuts more or less according to the length of the figures – which is purely accidental. What I have looked for in the Roses d'Antan is a decorative technique suitable for wood and since then I have attempted to follow this principle which leaves no place for the picturesque effects and sketchy drawings that I had made previously.' The notion that his style of drawing was simply a response to the needs of the material is somewhat ingenuous – there is more than a hint of the art of Morris in the foliate background – but it is also a clear declaration of the principles on which his art had developed since the end of the 1880s. It was also a repudiation of an improvised, more Impressionist drawing style which was not well adapted to print-making.

Camille's idea, however, of the difference between the 'Eragny style' and the English manner was not based on a simple opposition between rustic subjects and historical themes. Camille principally disliked the work of the English engravers because he thought it was conventional, cold and mechanical. What he liked in Lucien's work was its natural spontaneity, naivety and originality. It is this which explains Camille's ferocious criticism of Lucien's frontispiece to Verhaeren's *Les Petits vieux* [cat. 27] which he found uninspired and lacking in sentiment. This must have been particularly hurtful to Lucien as the frontispiece was based upon one of the early drawings for the first, unpublished French version of *The Queen of the Fishes* [cat. 9h] and must have seemed to Lucien an ideal example of the Eragny style which Camille constantly held up as an example to his son. Camille noted that he had seen the first signs of Lucien's decline in a woodcut of washerwomen made for Vollard in 1897 in the manner of the *Travaux des champs*: 'remain true to the rough manner of the Queen of the Fishes and you will thus make an art which is your own.'

Lucien, for a time, seems to have attempted to follow Camille's advice and returned for inspiration to his origins. As Anne Thorold has noticed, the frontispiece to Flaubert's *Un Coeur simple* [cat.24], published in 1901, is based on a watercolour of 1884 while the frontispiece of *C'est d'Aucassin et de Nicolete* [cat. 32] features a peasant girl, distantly related to the shepherdesses of Jean-François Millet and Camille. But, once again, Camille criticised the one and disliked the other.

The closing of the Vale Press and the death of Camille in 1903 mark a break in the history of the Eragny Press. This is visible in the use made by Lucien of the Brook type, designed by him in place of the Vale type which Ricketts had made available to him previously. The Brook type, although based on the Vale type, shows subtle but characteristic differences between the two which Lucien noted in a letter to his father: 'doubtless you will like

the irregular and dancing character of mine, it is greyer, thicker and also smaller than that of Ricketts.' The Brook series of books which began with Sturge Moore's *Brief History of the Eragny Press* [cat. 33] , also marks the end of Lucien's work in the 'Eragny style' with the notable exception of *La Charrue d'érable* [cat.47].

Because Lucien was distracted by his father's death and spent much of 1904 in France, *Areopagitica* [cat. 34]and the third book in the Brook series, Diana White's *The Descent of Ishtar* [cat. 35], were set up, engraved and printed by Esther. There were a number of disagreements between Lucien and Esther over details of the design and publication while the frontispiece to *The Descent of Ishtar*, drawn by Diana White, did not altogether appeal to Lucien. Like his father, Lucien had reservations about the lack of naturalism in English illustration: 'I cannot help thinking that Diana's first effort resembles work from the school of Birmingham, you will find that disagreeable, but it shows me how my work derives absolutely from the English Arts and Crafts movement.'

The distinction which Lucien made between the work of the later Pre-Raphaelites and the aims of the Arts and Crafts movement lies at the heart of his ambition to reconcile the innocence and naturalism of his French heritage with the ideals of English craftsmanship. Despite his admiration for the principles of Morris and Ricketts, he was never a wholehearted follower of their art. Comparison between Diana White's frontispiece and Lucien's frontispiece for his next book, his 1904 edition of *Some Poems* [cat. 36] by Robert Browning, shows what was distinctive in Lucien's work. By this date, he had perfected the art of combining a simple line block with several colour blocks, printed with a painterly irregularity somewhat in the manner of watercolour washes. The effect is light and decorative and set the pattern for most of the illustrated books in the Brook series, reaching an apogee in the sumptuous *Histoire de la reine du matin* [cat. 45] and in *Poëmes tirés du livre de jade* [cat. 46] completed in 1909 and 1911. The *Reine du matin* looks back to the images in Lucien's *Book of Ruth*, both exotic texts on Eastern themes, particularly to the engraving of the *Coronation of Esther* [cat.18c] which, like much of the *Reine du matin*, is touched by a debt to the Persian and Indian miniatures which both Camille and Lucien admired. Several of the illustrations include effects of marked recession between the foreground figures and the figures in the background but the sense of depth is consistently eliminated by the lack of modelling and by surface pattern. The same mixture of gold detail, coloured illustration, pattern and printed text was employed to exquisite effect in the *Livre de jade*, but with an even stronger sense of pattern and little indication of recession. The images in the *Reine du matin* illustrate a narrative while the *Livre de jade*, decorated with images of oriental women, is more evocative, more ornamental and less literal.

By comparison with most of Lucien's books after 1903, the last illustrated book in the Brook series, *La Charrue d'érable* [cat. 47], stands apart by its use of restrained ornament and dull colour. The style was determined by the subject matter, based on Camille's *Travaux des champs*, a series of drawings which began in the 1880s as a project for a book and

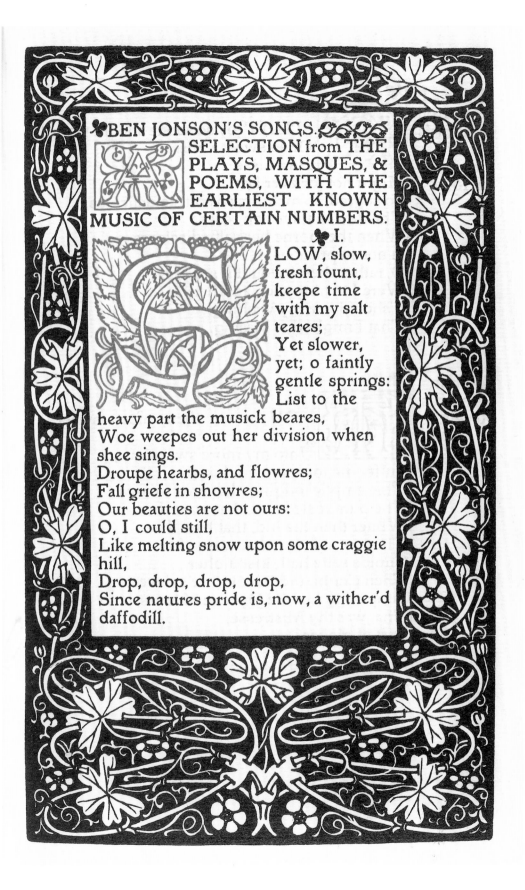

BEN JONSON'S SONGS.

A SELECTION from THE PLAYS, MASQUES, & POEMS, WITH THE EARLIEST KNOWN MUSIC OF CERTAIN NUMBERS.

I.

SLOW, slow, fresh fount, keepe time with my salt teares;
Yet slower, yet; o faintly gentle springs:
List to the heavy part the musick beares,
Woe weepes out her division when shee sings.
Droupe hearbs, and flowres;
Fall griefe in showres;
Our beauties are not ours:
O, I could still,
Like melting snow upon some craggie hill,
Drop, drop, drop, drop,
Since natures pride is, now, a wither'd daffodill.

went through many transformations before they were published in 1913. The origins of the book explain its retrospective character which is down-to-earth and understated by comparison with his recent books although, technically, it is a sophisticated and elaborate exercise in print-making in which Lucien brought into shape the rambling and protracted *Travaux des champs*. One of the difficulties facing Lucien in transferring Camille's drawings to wood blocks had been his father's difficulty in adapting his drawings to the demands of the medium. Lucien always copied his drawings with little variation to the woodblock. From 1891, he used photography to transfer the image. This left him little room for improvisation although from the late 1880s, he began to draw in a manner which anticipated the print, eliminating the stray pen strokes and impressionist touches which are commonly found in artists' drawings. Camille, however, was not a wood engraver and did not always understand Lucien's concerns. While working on another unrealised project, an illustrated *Daphnis and Chloe*, Camille confessed his difficulty in making drawings which were designed for wood and suggested that Lucien should design the series himself. Ricketts when consulted about this difficulty, told Lucien that it was up to him to interpret the drawings in converting them into print, a suggestion which perplexed Lucien who habitually respected every random stroke when transferring a drawing to the block. Lucien's concern with establishing the relationship between the preparatory drawing and the final engraving explains his excitement when he first came across chiaroscuro prints of the Renaissance in the British Museum. These offered an example of how to transfer drawings into prints without sacrificing the liveliness of the original: 'I have been studying the Italian chiaroscuros (engravings *en camaieux*) at the British Museum, my dear, there are astonishing things there and some impressions are really marvels which can stand comparison with the most illustrious of the Japanese in their boldness and even in the beauty of the materials ... this corresponds precisely to the kind of little drawings which we have made, but with an astonishing freedom. How many things there are to do, if only we had the time!'

With a promise of costs from the Société du livre contemporain, Lucien felt liberated to realise the long-running projected *Travaux des champs*. *La Charrue d'érable* is illustrated with twelve chiaroscuro prints after Camille's drawings along with ten coloured headpieces, ten initial letters and ten coloured tailpieces designed by Lucien and engraved in wood by Esther. Despite superficial differences with the *Reine du matin* and the *Livre de jade*, it is a lavish book in which style and ornament are skilfully adapted to the subject.

From the beginning of the Eragny Press, Lucien had hoped to find a market for his books in France. His efforts did not make the desired impression although he had important admirers like Roger Marx who first put Lucien in contact with Rodrigues, president of the Cent bibliophiles, or Auguste Lepère who followed the career of his former pupil with interest. Sales of his books in England and America never provided him with an adequate income but he could, at least, rely on a number of devoted bibliophiles on both sides of the Atlantic to buy his books. French collectors,

however, were less forthcoming despite his attempts to woo them with French titles and to find French outlets. Once Hacon and Ricketts had closed down the Vale Press in 1903, he decided to concentrate on English language books, living hand to mouth from one book to another, until the failure of the collection of Ben Jonson's songs in 1906 forced him to attempt, once more, to enter the French market. Thanks to the support of Marx, this period produced three of his finest books. It might have marked the beginning of a new era in the history of the Press but, in the event, it was a closing chapter. Lucien noted on more than one occasion that the conditions of war made sales more difficult than ever, raised production costs and prevented him from obtaining paper from his French supplier. The war, no doubt, made it impossible to continue but he had already decided to set printing to one side when the *Charrue d'érable* had been completed and to devote more time to painting. He was tired after working for two years in the face of constant difficulties and money was as ever in short supply. He did not intend to abandon his press entirely. As soon as the war was over, he designed an edition of William Cullen Bryant's *Thanatopsis* but abandoned it before it went into production. *Whym Chow* [cat. 48], a *livre de circonstance*, designed and printed by Esther and published in 1913, was the last Eragny book.

During the eighteen years between *The Queen of the Fishes* and *Whym Chow*, Lucien and Esther had issued only thirty-two titles. They were hindered by setbacks and the constant threat of insolvency, but the list which they produced, small though it is, includes some of the finest work produced by the English private presses. There is not one Eragny book that does not have a discreet and distinctive charm and several are among the most delightful publications in the history of printing.

LA grâce des saules, la délicatesse des fleurs subissent le temps capricieux, qui règne, vers cette époque des 'aliments froids'.*

MAIS quel que soit le temps, il est toujours difficile de trouver la juste harmonie des rimes.

CEPENDANT: voici que la poésie est terminée.

QUI donc soutient et console celui qui se réveille de l'ivresse?... de l'ivresse des poètes, qui est autre que celle du vin?...

VOICI que les cygnes sauvages ont fini de passer.

* Commémoration d'un deuil public.

CHOOSING THE TEXTS FOR
THE ERAGNY PRESS ✤

COLIN HARRISON

T HE HISTORY OF THE ERAGNY PRESS IS A HISTORY OF
pragmatism. Until 1903, Lucien and Esther Pissarro lived a
hand-to-mouth existence, depending on a monthly stipend
from Camille Pissarro in Paris, and they were never able to
make grandiose plans for their press. In spite of this, writers on the press
have attempted to construct a coherent programme of publishing based
on the texts that Lucien selected. Marcella Genz, for example, in her
substantial account, describes what she calls 'the Eragny Press publishing
programme'.[1] More recently, Alice Beckwith arranged her entire exhibi-
tion at the Grolier Club and elsewhere on the premise that 'the Pissarros
lived their lives and made their books with an eye to creating a world filled
with respect for themselves, for others, and for the beauty of nature.'[2]
However, Lucien himself admitted that 'For lack of capital, I was not able
to print the books I wanted to produce until the French began, at last,
to take an interest in the revival of printing'.[3] By this definition, only the
two books commissioned by bibliophilic societies, *Histoire de la reine du
matin* (1909) and *La Charrue d'érable* (1912), were commensurate with
Lucien's ambitions to produce books that were complete works of art, in
which typography, illustration, decoration, paper, and binding were all
harmonious and played their role in the general effect. Nevertheless, in
a letter to the literary agents Perris and Cazenove on 6 May 1904, Lucien
wrote that 'I shall be pleased to have advice and suggestions to the choice
of books. I can not undertake to do other than books that entirely appeal
to me, and must reserve absolute freedom as to decoration, arrangement,
and means of production'. A careful examination of Lucien's own literary
tastes, insofar as they can be determined, and the influence of his father
and of his mentors, Charles Ricketts and Charles Shannon, demonstrates
the complexities behind the choice of texts for the Eragny Press.
Lucien's own account of the origins of the Eragny Press stress that he only
began the enterprise because other publishers were not interested in his
children's stories, finding the colour printing too expensive.

Over thirty years ago I had a desire to produce illustrated books and I
planned two coloured books for children. These were submitted to several
publishers in Paris who objected to them mainly on the ground that they
would be too costly to produce. So it occurred to me that the cost would be
considerably reduced if I could engrave the line and colour blocks myself.'[4]

As the eldest of seven children, and a natural story teller, Lucien had

begun to invent stories for his younger brothers and sisters when he was a teenager. Greatly influenced by contemporary illustrators such as Walter Crane, he began to compose short illustrated stories for publication in periodicals, in a clear linear style with limpid colouring, mostly for the English market.[5] All were brief, and the subjects often reflected Lucien's upbringing, in particular the anarchist politics he shared with his father. Among the earliest were three versions of Gérard de Nerval's *Reine des poissons* prepared between 1889 and 1891: two were illustrated manuscripts of the French text, and the third, a suite of drawings intended for *The Child's Pictorial*.[6] It was natural, therefore, that the first book Lucien designed and published himself was an English translation of Nerval's tale. There is no evidence that Lucien intended to establish a private press at this stage, but this first book is characteristic of many of the later publications of the Eragny Press. The text is short – scarcely more than 1000 words – because writing and printing it were extremely time-consuming. The prospectus makes clear that, rather than an illustrated book with typography in the conventional sense, it was 'a printed manuscript decorated with pictures and other ornaments cut on the wood'.[7] Nerval's tale, first published as one of the *Chansons et Légendes du Valois* in 1854, and reprinted in *La Bohême galante* in 1856, was a fable rooted in popular folklore, and appealed greatly to Lucien's love of fantasy. *The Queen of Fishes* is characteristic of much of Lucien's work of this period, the subjects of several of his paintings and of his first portfolio of wood engravings also taken from fairy stories – Cinderella, Little Red Riding Hood – or children. It is also a precursor of the tales from Perrault published by the Eragny Press in 1899, 1902, and 1907.

The second of Lucien's books was originally planned as another hand-written text, and the first mention of the subject, in December 1894, was of 'Ruth et Booz'.[8] The story of the maiden reduced to gleaning in the fields and rescued by the landowner, Booz, was celebrated in France through Victor Hugo's poem, 'Booz endormi', in the *Légende des siècles*. Lucien soon decided to publish the whole of the *Book of Ruth*, which combined the timeless setting of the gleaning fields so familiar to Lucien from his childhood in Normandy, with the imaginary Orient he was to depict in several of his later books. However, the *Book of Ruth* was not substantial enough to stand alone, so, 'pour faire corps,'[9] he added the *Book of Esther*, a much less congenial work in artistic terms, but one which joined the names of his wife and sister-in-law, Ruth and Esther, who both served as models for the figures in Lucien's illustrations. It is difficult to determine whether these texts had any more personal significance for Lucien than the setting, and it would be wrong to infer that he was interested in their Jewish setting – his own marriage had been jeopardised by his implacable opposition to acknowledging any Jewish rites or traditions.

The third book published by the Eragny Press introduced a recurrent problem, which Lucien was never able to overcome, that of copyright in the text of contemporary authors, and the consequent possibility of having to pay a fee to another publisher or the author himself. On 23 January 1896, Lucien wrote to his father informing him of the three books he planned:

the book of Ruth and Esther, which was in hand; one or more of Perrault's fairy stories; and, 'si la permission est obtenue', Jules Laforgue's *Moralités légendaires*, with an article on the author by Félix Fénéon. The negotiations over the permission to publish Laforgue's text were protracted, and involved not only the author's brother, Emile, but also the *Mercure de France*, to whom Emile had given sole publication rights.[10] Eventually, Fénéon obtained permission for Lucien to publish the text free of charge. Lucien was familiar with the writings of Jules Laforgue long before he embarked on his edition, and may even have met the author as a boy, since Jules Laforgue's father, Charles, was a friend and business associate of Lucien's uncle, Alfred Pissarro.[11] Laforgue was an artist as well as a writer, a contemporary of Seurat at the Ecole des Beaux-Arts, and a friend of Charles Ephrussi, the owner of the *Gazette des Beaux-Arts* and an important collector of Manet and the Impressionists.[12] He was also one of the writers admired by Camille Pissarro and his friends, Octave Mirbeau and Félix Fénéon, and lionised in Symbolist circles in Brussels.

Initially, Lucien was still hoping to find a commercial publisher to take on the financial burden of the book. The most likely was Edmond Deman (1857–1918), who was the leading francophone publisher in Brussels, and closely associated with the Belgian Symbolists: he published the first editions of most of the works of Verhaeren, and books by Maeterlinck and other prominent authors.[13] Lucien had already tried to interest Deman in publishing an edition of Maeterlinck as a 'printed manuscript' in October 1894, but had failed to reach agreement. In August 1896, he proposed a new edition of Laforgue, going so far as to suggest that 'peut-être voudriez-vous éditer le livre en entier? Je m'adresse à vous en premier parce qu'il avait déjà été question entre nous de publication de beaux livres. Mon ambition est de produire des livres français réellement bien faits. Ayant à ma disposition et une typographie et une presse je suis à même de commencer'.[14] Soon afterwards, he explained that

> Je désirerais publier, si c'est possible, les plus importantes oeuvres du
> mouvement symbolique: Maeterlinck, Verhaeren, etc.; puis Verlaine, enfin
> tout ce qu'il y a de remarquable parmi les contemporains et en même temps
> faire paraître de temps en temps des oeuvres des poètes de la Pléiade et des
> classiques françaises.[15]

This should not be seen as an outline of a 'publishing programme' for the Eragny Press,[16] but as an attempt to engage Deman in publishing the Laforgue and further books that Lucien would design. So, the choice of texts corresponds almost exactly to those that Deman was already publishing, save for the mention of the occasional volume devoted to sixteenth- and seventeenth-century writers.

In the prospectus to the Eragny Press edition, John Gray emphasised that 'Laforgue's distinctive character as an artist is one which has ever been most salutary to the literature of his country. He was endowed with the special gift of satire which marks the keenest sympathies.' Laforgue's texts are essentially parodies of some of the most popular figures in European literature. The first to appear in Lucien's edition, *Salomé*, had become almost a cliché in contemporary literature and painting, and Lucien would

no doubt have been familiar with many other versions. Amid the wealth of literary and artistic precursors, Laforgue's tale is a satire on Flaubert's *Hérodias*, one of the *Trois Contes*. Lucien's two frontispieces to these volumes are inevitably Pre-Raphaelite in character, much closer to the work of Ricketts and Shannon than the Eragny School of Camille Pissarro; and the figures of Salomé and Ophelia, the latter completely irrelevant to Laforgue's tale, were inspired by contemporary artists rather than Laforgue's texts.

The difficulties in publishing Laforgue persuaded Lucien to write to his father that 'j'aurai soin dans le futur de ne pas publier des *modernes*'.[17] However, his next project was technically just as susceptible to copyright fees as the Laforgue. Ironically, Camille had earlier proposed Flaubert's *Trois Contes* in the belief that 'il n'y a pas de droit d'auteur, c'est libre'.[18] Camille's ignorance of copyright laws was shared by his son, who repeatedly failed to secure permission for texts in copyright, set them up in type, and was then forced to pay dues when the edition had already been announced.

Lucien shared with his father a great love of Flaubert's writings. Their sympathy was both literary and personal. Flaubert was born in Rouen, and lived most of his life in the vicinity. His realist novels, precursors of those by Camille Pissarro's friends Zola and Huysmans, portrayed provincial and city life and the hypocrisy of bourgeois morality. In 1857, he became the unwilling hero of one of the most celebrated trials of the nineteenth century, when *Madame Bovary* was imputed for offences against religion and public morals. His most ambitious book, and the most pleasing to the Pissarros' anarchist politics, was *Bouvard et Pécuchet*, left unfinished at the author's death and first published in 1881. It is a sustained and funny examination of the inadequacies of all systems. Significantly, one of Lucien's earliest works was an etching of 'Bouvard lisant *Le Temps* dans sa chambre à coucher';[19] and, years later, Lucien ruefully remarked, 'Vive *Bouvard et Pecuchet* – voilà un vrai bouquin'.[20] It was, however, not practical for Lucien to publish a long novel, and even Flaubert's *Trois Contes* were published individually. They would not have been his first choice, for, although the settings correspond to his interests – life in a small country town in the first two, and in the biblical lands he had already illustrated in Laforgue in the third – the Christian apotheosis of the hero in each can hardly have been sympathetic to a confirmed anarchist of Jewish descent. Once again, Lucien's frontispieces do not illustrate the most dramatic moments of the stories, but are entirely personal interpretations – there is nothing of the stained glass window that inspired Flaubert's *Légende de Saint Julien l'Hospitalier* about Lucien's engraving of a deer grazing in a forest with bunny rabbits besides.

However, Lucien may well have been persuaded to publish the *Trois Contes* because of the enormous reputation they enjoyed in England. Walter Pater, who was instrumental in promoting both modern and medieval French authors in England, and who greatly admired the Romanticism of Baudelaire, Gautier, and Victor Hugo, reserved a special place for Flaubert, whom he described as 'the martyr of literary style'; Arthur Symons remembered that 'of Flaubert we rarely met without speaking'.[21] After Pater's meeting with Oscar Wilde in 1877, he gave him a copy of

Flaubert's *Trois Contes*, the last of which, *Hérodias*, Wilde adapted for his own play *Salome* (1891).

The publication of the *Trois Contes* was spread over two years, and shared with two volumes of poetry by the colourful and anarchic figure, Francois Villon (1431–*c*.1463). He led an extraordinary life, participating in theft, civil disturbance, and even murder before dying at the age of about 32 or 33. His poetry was a great Romantic rediscovery: the first critical edition came out in 1832, and Théophile Gautier honoured him as the first of his studies of *Les grotesques* in 1856, claiming that 'Villon fut le plus grand poète de son temps'. Lucien owned both the standard editions published in his lifetime, that of 1867, and that of 1892 by Auguste Lognon, still the basis for all subsequent work on the poet. More personally, he would have enjoyed one of Villon's most celebrated quatrains which reads: 'Je suis François dont il me poise / Né de Paris emprès Pontoise'. However, it was probably Villon's reputation in England that persuaded Lucien that the publication of a selection of his poems would be commercially worthwhile, for he was widely considered a precursor of the *poète maudit* invented by Mallarmé. Swinburne, who had begun a translation as early as 1861, transmitted his enthusiasm to D. G. Rossetti, who included his own versions of three poems in his *Poems* of 1870.[22] Villon's reputation as a *poète maudit*, poor, passionate in love and literature, and a rebel against convention, persisted into the 1890s, with almost the only dissenting voice being Robert Louis Stevenson, who in 1877 hailed him as the precursor of the French Realist writers, Flaubert, Zola, and the Goncourt brothers.[23] Whichever interpretation Lucien preferred, he can reasonably have hoped that his two volumes would find favour in both London and on the Continent. The first volume opens with the most celebrated of Villon's ballades, the 'Ballade des dames du temps de jadis', with its languid refrain 'Où sont les neiges d'antan'; and the second, a miscellaneous and slightly unfortunate compilation of 'Autres poésies', includes one of the best, 'Les regrets de la belle heaulmière', but also includes seven works of doubtful authenticity to make up numbers. Although Lucien used what he believed to be the standard edition, by Pierre Jannet,[24] he took certain liberties, omitting, for example, the fifty-two lines of the double ballade in 'Le dit de la naissance de Marie d'Orleans'. More importantly, in neither volume did he include Villon's most substantial works, the 'Lais' and the 'Testament', presumably because of their length. This severely limits the usefulness and bibliophilic value of the Eragny Press edition. Nevertheless, all 200 copies sold in London,[25] confirming the trend that the French books sold better in England than in France.[26]

Lucien's admiration for Villon was shared by John Gray, a friend of Ricketts and Shannon and one of the main contributors to *The Dial* – Lucien lent him his own copy of Villon when he first settled in London in 1890[27] – and Lucien's debt to Ricketts and Shannon and their circle can be seen in many of the later publications of the Eragny Press. Most were in English, but even those in French would certainly have been discussed by the Vale circle. Indeed, Lucien seems to have intended many of his books to complement those of his friends. So, the Vale published editions of Browning in

1899, and of Mrs Browning in 1897, and Lucien his own edition of Browning in 1904; the Vale editions of Keats and Shelley of 1898 were followed by the Eragny edition of Keats's *La Belle dame sans merci* as a New Year book for 1906; the Vale Coleridge of *The Ancient Mariner* (1899) supplemented by the Eragny Coleridge in 1904. For their edition of Coleridge, the Pissarros were greatly indebted to Thomas Sturge Moore, who advised them that 'Christabel would be all right even though it is unfinished [because] it is the best known of Coleridge's poems after *The Ancient Mariner*. If you liked to print *Kubla Khan* with it you would have printed the two poems of his which have the greatest reputation after the *Ancient Mariner* which Ricketts did'.[28] Moore again provided advice on the text for Ben Jonson's *Songs* (1906), which 'sold deplorably',[29] and was rewarded with an edition of his own poems, *The Little School* in 1905. It must have seemed inevitable, too, that Lucien should have included one member of the Rossetti family in his publishing, for the influence of D. G. Rossetti was inescapable in the Ricketts-Shannon circle; Lucien's own book on Rossetti was published by Jack in 1907.[30] It was presumably whilst preparing this curious potboiler that Lucien discovered the early poems of Christina Rossetti, described in the preface as a 'literary curiosity'. Naively, he had set up the type and advertised the volume without ascertaining whether they were still in copyright, and was obliged to pay £25 to the surviving Rossetti, William Michael. The Eragny publication in 1904 of Milton's *Areopagitica*, subtitled 'For the liberty of unlicenc'd printing', was therefore extremely personal.

Among the older French texts published by the Eragny Press, *C'est d'Aucassin et de Nicolete* (1903) had been extensively discussed by Walter Pater in *The Renaissance* (1873), which had inspired several scholarly editions in England. For Pater, this tale illustrated the subversive and secular quality of life in medieval France, exemplifying his notion of a proto-Renaissance in France.[31] He records that the story came from the south of France, perhaps from Provence, and that it had 'traces in it of an Arabian origin, as in a leaf lost out of some early *Arabian Nights*.'[32] Whether Lucien discovered the tale for himself or heard about it from his English friends, the opportunity to combine the printing of text with musical notation was made all the more attractive by the setting and the popular nature of the text. The companion volume, *Some Old French and English Ballads*, goes further in making explicit the role of folk tales in the dissemination of popular poetry and songs.

Among living authors whose work Lucien wished to publish, Emile Verhaeren was another friend he had made through his father.[33] Like the Pissarros, Verhaeren was an anarchist. Lucien genuinely admired his poetry, telling his father that it was 'pleine de charme'.[34] In 1896, he illustrated 'C'est la ville de douleur' in the *Almanach du père Peinard* .[35] In the same year, Lucien introduced Verhaeren to Ricketts and Shannon on a visit to London, and arranged for a specially written poem to appear in *The Dial* free of charge, even though Ricketts and Shannon found him 'dull beyond belief'.[36] It was probably during the author's visit to England in spring 1900, when he gave a lecture at Oxford published as 'French Poetry of Today', that he arranged with Lucien to publish *Les Petits vieux* on the

Eragny Press.[37] Lucien thus followed in the glorious footsteps of Odilon Redon in illustrating Verhaeren's works. Regrettably, there is no surviving correspondence about the edition. Verhaeren also advised on the possibility of an edition of *Les Fleurs du mal* by Charles Baudelaire, another of the *poètes maudits* admired and promoted by Pater.

A few years later, in 1905, Lucien explored the possibility of commissioning a short work ('opuscule') from Anatole France for his press. By this date, France was rich and famous, and a member of the Académie française. Nevertheless, he was still utterly sceptical in politics and religion, and strong in support of Dreyfus and the working man. His novel *L'Affaire Crainquebille* (1901) was described by George Orwell as 'a devastating attack on "law and order"'. France did not respond to requests from Lucien and Fénéon to write the piece.

The two books that fulfilled Lucien's own definition of his creative ambitions fall into the familiar categories of the exotic and the pastoral. Both were commissioned by bibliophilic clubs in Paris. For the Société des Cent Bibliophiles, he effectively had a completely free hand over text and illustrations. He chose Gérard de Nerval's *Histoire de la reine du matin et de Soliman prince des genies*, a strange tale extracted from this author's *Voyage en Orient* (1851). In circumstances reminiscent of Scheherazade's story-telling in the *Thousand and One Nights*, a professional story-teller in a café in Constantinople described how Adoniram, an architect and bronze founder of immense skill, employed by King Solomon in his temple, fell in love with Balkis, Queen of Sheba, who was to be married to Solomon. The strangeness of the tale is matched by the complexity of its imagery, which Lucien translated into illustrations similar to those he had first used in the *Book of Esther*. It is unlikely that Nerval's text had any particular personal significance for Lucien, though he had planned an edition of it as early as 1902.[38]

The only deeply felt ambition Lucien had as a designer of books was a collaboration with his father, which was eventually realised in the last of the Eragny books, *La Charrue d'érable* (1912). It came as the culmination of a project begun nearly thirty years earlier. In 1895–6, Camille had provided designs for an edition of *Daphnis et Chloe* which Lucien intended to rival and outdo the edition published by the Vale Press in 1893; this came to nothing.[39] The second joint project, to publish a series of drawings by Camille of rural activities, was first discussed in 1886 as a conventional illustrated book. The publication of the portfolio *Travaux des champs* in 1895 was followed by plans for a second portfolio, but both Camille and Lucien still intended to produce a book incorporating Lucien's engravings after his father's drawings. In 1900, they approached Benjamin Guinaudeau (b. 1858) to provide a text.[40] He had recently become celebrated for exposing child abuse among the clergy in articles in the newspaper *L'Aurore*, 'Les crimes des couvents, l'exploitation des orphelins'. The Pissarros still did not have a clear idea of the nature of the text they required, and negotiations collapsed on Camille's death in 1903.

Lucien, however, still hoped to produce a book illustrated by his father, and the commission from the bibliophilic society, *Le Livre contemporain*, at

last gave him the opportunity. Once again, the negotiations were protracted, not least because of need to commission a suitable text. Lucien wrote to Pierre Dauze, one of the founders of the society, in 1910 that 'j'avais pensé à un texte soit de Renard ou de Theuriet'. Of these two writers, André Theuriet (1833–1907) was celebrated for his charming evocations of life in the countryside, notably the full-length novel *La reine des bois* (1890); and *La Vie rustique* (1888), illustrated by Léon Lhermitte and others. Since he was already dead, Dauze approached Jules Renard (1864–1910), a contemporary of Lucien's who shared his pacifist and anticlerical views. More importantly, he wrote with great sensitivity about the countryside of the Nièvre region. Unfortunately, he was already very ill, and died before any contract could be signed. Dauze's eventual choice was Emile Moselly (1870–1918), a schoolmaster born in the Bibliothèque nationale but brought up in Lorraine, where his family originated. He won the Prix Goncourt in 1907, and produced a succession of books inspired by the countryside and customs of Lorraine, most topically *Joson Meunier, histoire d'un paysan lorrain* (1910). During the summer of 1910, Dauze opened negotiations with Moselly, and by 3 October was able to tell Lucien that he had concluded the agreement. Lucien wrote back on 5 October that 'je suis bien heureux que vous ayez enfin trouvé un écrivain pour notre texte.' The logistical and practical details of providing texts appropriate to Camille's compositions were extensive, and, although Lucien sent the general 'plan définitif' to both Dauze and Moselly on 29 October 1911, Moselly's texts were not completed until early in 1912. It was Moselly who suggested the title, and Lucien wrote to him on 19/20 January 1912 that 'Votre titre *La Charrue d'érable* me paraît en effet à la fois vague et poétique et d'un caractère assez général pour indiquer la série de nouvelles.' At much the same time, Moselly wrote 'je prends la liberté de vous faire remarquer l'extrême variété de décor, 2 contes lorrains, 1 Beauceron, 1 normand.' Of the ten tales, four are set in Moselly's Lorraine, two in Lucien's Normandy, and the others in the Ardèche, the Franche-Comté, and the Beauce. In spite of this geographical diversity, Moselly had apparently intended to visit Gisors, to see for himself the landscapes that inspired Camille's drawings.

La Charrue d'érable fulfilled Lucien's ambition to make chiaroscuro wood engravings after his father's drawings, and include them as illustrations to a text. The correspondence between Lucien and Moselly does not dwell on the content of the stories, but only on their length – it was imperative that they should be exactly the right length to fit the number of pages available according to the rigorous budget set out by Rodrigues. It also exemplifies Lucien's attitude towards the relationship between pictures and text throughout his career as a designer and publisher of books. For Lucien's imagination was more visual than literary, and the choice of texts depended much more on the illustrations they suggested than the meaning they carried. Hence, many texts which might have seemed unsympathetic to the shy and insecure anarchist in London were transformed into some of the best of the Eragny books. Among these are the orientalist tales from the Bible, Nerval, Flaubert, and Judith Gautier, which were inspired by Lucien's love of oriental art, both the Japanese prints he had admired with his

father, and his familiarity with the heterogeneous collection of European and Japanese art and antiquities formed by Ricketts and Shannon, one of the most important in London. Less unexpected are the fairy stories and pastoral scenes Lucien had grown up with, which were sometimes adopted for surprising texts, such as Flaubert's *Un Coeur simple*. However, as Lucien told Dauze during the genesis of *La Charrue d'érable*, 'il me semble que l'illustration n'a pas besoin d'être trop conforme au texte – et ce qui est bien littérairement n'a pas besoin d'être représenté plastiquement'.

1. Genz, pp. 78–82

2. Beckwith, p. 6

3. Notes on the Eragny Press, p. 6

4. Notes on the Eragny Press, p. 3

5. Details are given in Thorold 1983, pp. 4–10

6. Thorold 1993, p. 127

7. Genz 2004, p.148

8. Thorold 1993, p. 389

9. Thorold 1993, p. 447

10. Thorold 1993, p. 472

11. Jean-Jacques Lefrère, *Jules Laforgue* (Paris, 2005), p. 83, 93

12. Ibid, p. 160; see also *Jules Laforgue: Textes de critique d'art*, ed. Mireille Dottin (Lille, 1988)

13. See Adrienne et Luc Fontainas, *Edmond Deman, éditeur (1857–1918): Art et édition au tournant du siècle* (Brussels, 1997)

14. Lucien to Deman, 4 August 1896, quoted in Adrienne et Luc Fontainas, *Emile van Balberghe, Publications de la librairie Deman: Bibliographie* (Brussels, 1999), p. 331

15. Lucien to Deman, 15 August 1896 (PFA, Oxford)

16. As Beckwith does, p. 6

17. LP to CP, 22 December 1896; Thorold, p. 522

18. CP to LP, 26 February 1896; Thorold, p. 464. In fact, the copyright on Flaubert's writings subsisted for fifty years after his death in 1880.

19. Sent by Camille to Esther in December 1885; Thorold 1993, p. 53

20. LP to CP, 29 October 1901; Thorold 1993, p. 700

21. See John J. Conlon, 'The reception of French literature in England, 1885–1914', *Studies in Anglo-French Cultural Relations: Imagining France*, ed. Ceri Crossley and Ian Small (Basingstoke, 1990), pp. 34–46 (41)

2. See Glen Omans, 'The Villon Cult in England', *Comparative Literature* XVIII (1966), pp. 16–35 (19)

23. Omans, p. 29

24. Lucien to Camille, 9 September 1896; Thorold 1993, pp. 493–4. In fact, a more authoritative edition, still the standard, by Auguste Longnon, was published in 1892.

25. As Lucien told his father in January 1900; Thorold 1993, p. 635

26. LP to CP, 27 September 1898: 'je vends plus de mes livres français à Londres qu'à Paris'; Thorold 1993, p. 579

27. Thorold 1993, p. 155

28. Moore to Pissarro, 14 June 1904

29. Draft letter from Esther Pissarro to Moore, 1906

30. Joseph Darracott, *The World of Charles Ricketts* (London, 1980), pp. 31–2

31. See John J. Conlon, 'The reception of French literature in England, 1885–1914', *Studies in Anglo-French Cultural Relations: Imagining France*, ed. Ceri Crossley and Ian Small (Basingstoke, 1990), pp. 34–46 (36–8)

32. Walter Pater, *The Renaissance: Studies in Art and Poetry* (London, 1922), p. 16

33. Thorold 1993, p. 282

34. Thorold 1993, p. 389

35. Thorold 1993, p. 428

36. Maureen Watry, *The Vale Press: Charles Ricketts, a Publisher in Earnest* (New Castle, Delaware and London, 2004), p. 107

37. Jacques Marx, *Verhaeren: Biographie d'une oeuvre* (Brussels, 1996), p. 388

38. LP to CP, 1 March 1902; Thorold 1993, p. 723

39. Brettell and Lloyd, p. 59

40. See Bailly-Hertzberg V, p. 128

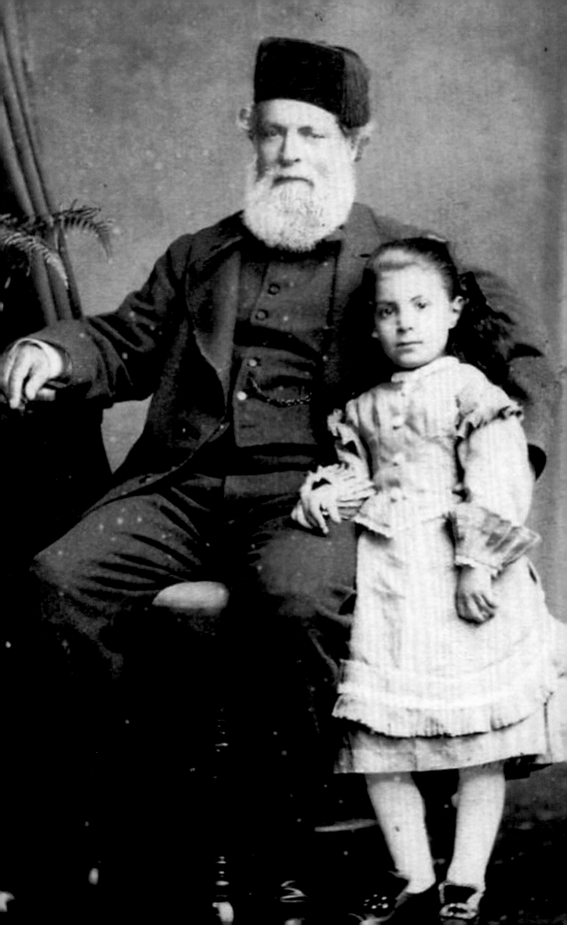

LUCIEN AND ESTHER PISSARRO –
AT HOME 1894–1914 ❧

SIMON SHORVON

AN APPRECIATION OF THE ERAGNY PRESS REQUIRES AN understanding not only of the artistic influences on Lucien and Esther Pissarro, but also their personalities and the domestic environment in which the books were produced. This is probably more true of the work of the Eragny Press than of that of the other private presses of the period, not least because Lucien in particular saw life and art as indivisible and lived his life though the precepts of his art. Lucien had, in his father's words, 'a naive and discreet nature' and was, according to John Rewald, 'a wonderful person … the kind and modest artist who had gone his own way according to the dictates of his conscience and his exquisite sensibility.' William Sutton Meadmore aptly subtitled his biography of Lucien *un coeur simple* after the title of Flaubert's story which was the eighth book printed by the Eragny Press. The emphasis Lucien placed on being true to his nature in his art and in his life, and on his artistic integrity, was to be a recurring theme in the recollections of all who knew him or wrote about him.

Lucien Pissarro was the eldest of Camille Pissarro's five sons. All five became artists but it is Lucien who has always had the highest reputation. Camille recognised his own artistic legacy in Lucien and encouraged and advised his son throughout his life. They shared a remarkable vision and sensitivity but Camille remained the major influence and inspiration in Lucien's art. Lucien's own life reiterated many aspects of his upbringing in France. For most of his childhood, he had lived in sustained poverty. His mother could not tolerate the lack of money but it seems to have passed unnoticed by Camille, who famously disdained money and recognition. There were also periods of disruption, including the war of 1870 which caused Camille and his family to flee for a short period to London. Lucien was six years old at the time. During their absence, the Prussian army occupied the Pissarros' French home and used Camille's paintings as duck-boards and butchers' aprons. In spite of these privations, at the heart of Lucien's childhood was a warm family life surrounded by art and artists, large family lunches, loving parents, and a hospitable house with frequent visitors who included Monet, Cézanne, Gauguin and Van Gogh. The company of these artists was inevitably an influence on Lucien, who drew and painted from an early age. His work as a child was warmly praised by Camille and Monet. Camille was proud of his son's artistic talent and did everything he could to nurture it. He wanted Lucien to take up painting

Fig.5 | Photograph of Esther as a child with her father Jacob. Private collection.

and to become an artist. Lucien's mother, Julie, on the other hand, furiously tried to dissuade her sons from following their father's example because of the indigence and insecurity the family had suffered. It was Julie who decided that Lucien [fig. 13] should move to Paris to work as a clerk in his mid-teenage years to start out in commerce, much against Camille's inclination, and when this proved a failure it was Julie who persuaded him to send Lucien to London. In 1883, Lucien arrived in London to live with his uncle, Phineas Isaacson, in Holloway. The main purpose of the sojourn was to teach Lucien English with a view to a business career, and Julie hoped that the stay with an English middle-class family would encourage him to give up his ambition to be an artist. However, Lucien spent much of his time visiting galleries and exhibitions, and exchanging letters with his father about English art. He returned to France in 1884 by which time the Pissarros' financial situation had worsened, and by 1887 they were in crisis. Lucien went to work at a printing workshop managed by Michel Manzi, and there learned the essentials of colour printing. Then in 1890 he moved again to London and remained resident in England for the rest of his life.

Lucien had met Esther, a friend of Phineas Isaacson's daughter, on his earlier visit, but was at that time too shy to strike up a friendship. In 1889, however, Esther visited Paris on a family holiday, and it was there that they formed their lifelong attachment. They explored art galleries and spent much time together and when Esther left Paris, they became frequent correspondents. No doubt it was to renew his acquaintance with Esther that Lucien agreed, the next year, to move again to London. Esther's background was very different from Lucien's. She was brought up in a prosperous middle-class environment, the daughter of Jacob Samuel Levi Bensusan, a successful Jewish ostrich feather merchant. Her father was an orthodox Sephardic Jew, and Esther had an upbringing which was both strict and restricting [fig. 5]. When she began to associate with the penurious anarchist artist Lucien, Esther's father forbade any further contact. Meetings between Esther and Lucien had to be arranged in secret and violent confrontation with her father followed when this was discovered. In 1892, when Lucien proposed marriage to Esther, Jacob threatened to disown and dispossess his daughter. Camille tried to intercede by visiting Jacob, but this did not help, despite their shared Sephardic descent. When a union seemed inevitable, Jacob insisted that they should be married in a synagogue, that their children should have a Jewish upbringing and that any sons should be circumcised. Esther loudly refused on all counts. The marriage nevertheless went ahead (in the absence of Jacob, but in the presence of his confidential clerk to ensure that the ceremony had a legal basis) on 11 August 1892 and the couple remained inseparable for the rest of Lucien's life. There was one child from the marriage, Orovida, born in 1893.

One cannot but be struck by the similarities between Esther and Lucien's marriage and that of his parents. When Camille went to live with Julie, Camille's own parents vehemently opposed the union. Julie was non-Jewish, poor and an assistant cook in Camille's parents' household and considered a totally unsuitable match; and in fact they were not formally married until 1871 (in London) after Camille's mother had died,

by which time Lucien had already been born. Julie, like Esther, was loud garrulous and determined, and Camille, like Lucien, quiet, modest and impractical. Julie like Esther was vested with the task of making ends meet, while Camille, like Lucien, was to devote his life to his art. Both Julie and Esther were vehement in the protection of the work and reputations of their spouses, both in their husbands' life- times and after they had died.

Lucien also shared with his father a way of life that extended beyond their art. Both Lucien and Camille (and also Esther) had rejected the religion and ritual of Judaism. Their art was not influenced in any way by their ancestry nor by the religion of their ancestors but both remained identifiably Jewish throughout their lives. This was clear from their correspondence and from their response to the Dreyfus Affair which was a defining moment in French Jewish life. Another shared strand was their association with the Anarchist movement. Both Camille and Lucien were anarchists (as were Signac, Van Rysselberghe and Luce). Both disdained money and capitalism, shared a romantic attachment to nature and the countryside, admired the simple life of the peasant and deplored the effects of industrialisation. Both contributed graphic art to anarchist journals and publications, focusing on the life of rural poor, scenes of utopian Nature and, to some extent, urban capitalism. However, while politically associated with the far left, neither Camille nor Lucien were temperamentally 'political', and neither were activists. Their mainstream work, including Lucien's work for the Eragny Press, was completely devoid of any overtly political tendency. They were both 'gentle anarchists', illustrating the lives of the rural poor, certainly, but the primary philosophy of their art was truth to nature and to light and colour, and not to politics. In London, Lucien moved in Socialist and Fabian circles, but at the periphery. Esther too had become a Socialist, as had many educated middle-class women at that time, and she attended Socialist meetings in Hammersmith with Lucien and other artists of the period, including William Morris and Ricketts, both of whom influenced his book work. Like Lucien, however, she was never 'political' in the public sense.

The primary artistic influence on Lucien's life and art was French Impressionism and particularly the example of Camille. Lucien, from an early age, was bathed in the light of Impressionism and throughout his formative years was guided daily by his father. Their voluminous correspondence is evidence of Lucien's deep understanding of, and total sympathy with, the theory and practice of Impressionism. When he moved to London in 1890, he was already in the vanguard of the younger generation of French artists who were leading the evolution of the movement into Neo-Impressionism and Post-Impressionism. In this period, for the only time in his life, he was in the avant-garde. His early paintings – especially those in the pointillist style – are of the highest quality. Furthermore, Lucien was well known and on friendly terms with Seurat, Signac, Luce and Van Rysselberghe, leading artists of the Neo-Impressionist group, as well as with Monet, Cézanne, Van Gogh and Gauguin and others in his father's circle. He was at the centre of French artistic life, and had he stayed in France, it seems likely that his art would have followed a Post-Impressionist course [fig. 6].

Although his chief works in the 1880s were oil paintings and drawings, executed in a style and technique learned from his father, he had already shown a strong interest in printing, engraving and woodcutting. He had learned wood engraving in the mid-1880s, under the tutelage of his father's friend, Auguste Lepère, and in 1887, while working for Manzi, he had acquired some experience in colour printing, both of which became integral in the work of the Eragny Press. In the 1880s, along with Camille and Camille's other sons, Rodo, Manzana and Félix, he provided illustrations for articles by Félix Fénéon, published in Emile Pouget's famous periodical, *Père Peinard*. These woodcuts and other illustrations from this period were often of a political character but his paintings retained their hermetic Impressionist nature without any political connotation [fig. 7].

It was with this background that Lucien moved to live permanently in London in 1890. He lived first in Bayswater, and there, through an introduction by Fénéon, he was introduced to Charles Ricketts. Ricketts was to become one of his closest friends. It was through him that he became acquainted with Morris, Crane, Sickert and Sargent. In this company, he was exposed to the avant-garde of English art and illustration, to the Pre-Raphaelite and Aesthetic movements, and to a symbolist style at total variance to Impressionism. He moved into a circle which was Socialist in tendency, but he seems to have lost any desire to take part in political activism. Perhaps the greatest English influence on his work was that of the Arts and Crafts movement with its reaction against soulless machine-made production and industrialisation applied to art. A central Arts and Crafts aim, strongly advocated by Morris, which appealed to Lucien particularly, was the abolition of the division of labour and the revival of the master craftsman who is involved in all stages of the creation of his work, albeit with the help of apprentices and creative like-minded workmen. He applied this Arts and Crafts principle in the productions of the Eragny Press which were hand-crafted at almost every stage by Esther and himself. It was a principle which was in tune with the beliefs he was brought up with, beliefs

Fig. 6 | Lucien Pissarro *Eragny Church*. Oil on canvas 530 × 720 mm.

Fig. 7 | '*Le père peinard*' Almanack for 1896. Private collection.

in the primacy of art and the integrity of art and life. One senses that this concept took the place of the less private anarchism of his youth. In the end, Lucien was never a political person in the public sense, although he remained true to the romantic ideals of the master craftsman.

It was in this artistic environment that Lucien began to evolve his own original style and applied this to his woodcuts and engravings. The style with its mixture of French Impressionism, English Arts and Crafts and Symbolism was widely admired in Morris's circle. Camille, however, disapproved of the historicist and symbolist elements in these works. On the other hand, these elements are notably absent from Lucien's paintings which remained wholly true to the principles of Impressionism. Appropriately, when he married Esther Bensusan in 1892, Ricketts, Shannon and Camille were all present, witnesses to the marriage as they were to his art.

In 1893, Lucien and Esther moved to Epping where their only child, Orovida, was born in October. Lucien wrote that the only thing that then mattered was that she should become an artist. By this date, although still primarily a painter, Lucien was spending much more time on his woodcuts. His friendship with Ricketts also allowed him to take up book-making and to use his skills in colour printing in the books. Ricketts had begun publishing a magazine, *The Dial*, from 1889, and in 1893 he initiated his own press – the Vale Press. He created a typeface – the Vale typeface – which Lucien thought 'one of the most beautiful which has ever existed.' Ricketts instructed Lucien in the technique of engraving, and became Lucien's mentor in all matters relating to book-making.

In 1894 Lucien embarked on his independent bookmaking career, creating the Eragny Press, named after Eragny-sur-Epte the small Normandy village which had become the home of the Pissarro family in 1884. In Epping, Lucien had also named the small cottage they rented 'Eragny Cottage', and it was here that the designs and engravings for his first books were produced. Initially, the printing was carried out by Lucien using the premises of a local printer, Alfred D. Davis, from whom Lucien hired out space, the printing press and one of the printer's workmen. The first Eragny press book, *The Queen of the Fishes* [cat. 17] was a fairy tale translated by Lucien's friend Margaret Rust. In 1894, the Vale Press had found a financial backer, the barrister William Hacon, and in 1895, Lucien and Ricketts agreed that the Eragny Press books could be distributed with those of the Vale Press. These early books carry the imprint of Vale Publications, and are printed using the Vale typeface. Three further books were completed in Epping with some influence from the historicist style of Ricketts but without the subtle colour range of *The Queen of the Fishes* or of Lucien's later work, possibly because of lack of finance

With his book-making now established, and following the birth of Orovida [figs. 8–9], the cottage in Epping was proving too small and Epping too isolated, and Lucien and Esther decided to move. The relationship with the Epping printer, who had difficulty meeting the very high standards of craftsmanship and workmanship which Lucien expected, was also causing dissention. The Pissarros chose to settle in Chiswick in West London where they lived for most of the rest of their lives. They initially

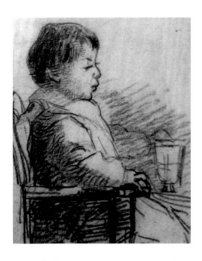

rented a house at 62 Bath Road from a fellow artist. This had a large studio which was to become Lucien's print room. The location was not new to Esther as her art teacher at the Crystal Palace School of Art, Archibald MacGregor, lived at Stamford Brook House. Esther and her closest friend of those years, Diana White, were frequent visitors to the MacGregors, for whom Diana often posed as a model. It must have been Mr MacGregor or Diana who found number 62 Bath Road, 300 yards from Stamford Brook House.

Chiswick and Hammersmith, neighbouring localities in West London, were then a centre of artistic activity, not least of fine printing. The Chiswick Press, founded by Charles Whittingham in 1811 in Chiswick Mall, was a precursor of the private presses and published some of the early designs of William Morris. The first private press, the Kelmscott Press, founded by William Morris in 1891, and the Doves Press of T. J. Cobden-Sanderson and Emery Walker were both located in Hammersmith, within a mile of the Bath Road. Morris, Cobden-Sanderson and Emery Walker all lived in Chiswick, and their proximity and that of the presses must have provided a stimulating environment for the nascent Eragny Press. The area was also the home of an artistic colony, based in Bedford Park, the first garden-city and with houses by Norman Shaw, E. J. May and E. W. Godwin. Amongst the other famous residents within a mile of the Pissarro household, and known to Lucien, were the artists Jack Yeats, T. M. Rooke, J. Nash and the architect Charles Voysey, who also built a house in Bedford Park. The Chiswick School of Art was less than 300 yards away from Lucien's home and was an active centre of the Aesthetic movement and Pre-Raphaelites. Vincent Van Gogh drew in the area and may have taught at the school. By the time Lucien moved there, Bedford Park had become a recognised centre of the Arts and Crafts movement, notable for its Arts and Crafts architecture. As Ricketts told Lucien, the 'elect of the art world' lived in Bedford Park.

The Pissarros moved to Bath Road in the spring of 1897 and lived there for six years. Lucien and Esther must have looked forward to the move, not least because it would end Lucien's artistic isolation in Epping and because

Fig.8 | *Orovida Pissarro* by Lucien Pissarro. Private collection.

Fig.9 | Orovida, viewing *Portrait of Jeanne Pissarro* by Camille (1872) at an exhibition at the Tate Gallery, 1961.

the larger space was going to allow not only the design but also the printing work to be carried out entirely in the home environment. However, disaster struck in May 1897 when Lucien suffered a stroke. The evening before, he had dined with Ricketts and returned home late. On awakening in the morning, he was reportedly tired and unable to work and in the afternoon was found collapsed in his studio. He was drowsy, had a paralysis of the left arm and his right eye was closed. He recovered somewhat by the next day, but later relapsed into unconsciousness and then confusion and delirium. He made a slow recovery, needing initially to be wheeled around Chiswick by Esther in a bath chair. Within six months he could write that he was much better. This illness had been preceded in the months before by episodes of vertigo. Lucien had also complained that the two fingers of his left hand had been numb for several years. Exactly what the illness was is unclear. His doctor, McNish, diagnosed a stroke. The symptoms of the acute attack are indeed typical of a small posterior circulation stroke, but his age at the time (44 years) is uncommonly young for an attack of this kind, and the earlier symptoms raise the possibility of other pre-existing conditions. Time however obscures the possibility of certain diagnosis. However, what is clear is that his artistic path was diverted by the illness. Physically his stroke resulted in a permanent clumsiness of his gait, and his left hand remained partially paralysed. One suspects it also narrowed Lucien's artistic horizon. In the earlier years, Lucien was in the avant-garde, he experimented with new styles and with new methods. His early Post-Impressionist pointillist work was amongst best of the period. After this episode, however, his oil painting suffered. He stopped painting completely for three years and only really returned to regular oil painting eight years later although his painting never recovered the vitality of the earlier work.

His efforts during these years were largely devoted to his press. The change may have been due to the effects of the stroke on his energy levels, his dexterity or his mobility – perhaps a mixture of all three. He painted with his right hand and one would not have expected this to be markedly affected, but his walking and his stamina were curtailed. What is clear is that his intellect was unaffected, as would be expected in this variety of stroke, and any change in style was not due to any dulling of his talent or ability. Sometimes a stroke restricts horizons and precipitates reassessment and revision, and this too may have accounted for his more limited output. Whatever the reasons, and they are not clear from his writing at this period, Lucien's artistic course was to change from this point onwards.

On 7 May 1897, Camille Pissarro wrote to Durand-Ruel that he had 'to leave everything and hurry to my son Lucien who is gravely ill.' This was Camille's fourth and last visit to London and he stayed with Lucien and Esther in Bath Road. Here he painted seven oils of the vicinity, including a cricket match on Acton Green [cat. 3], a painting of the local fete for Queen Victoria's Diamond Jubilee, a painting of the green adjacent to Lucien's house and a painting of the railway branch-line which ran beside the house. Photographs exist of Camille painting on the balcony of Lucien's house and it is possible now to reconstruct the sightlines of his paintings [fig. 10]. One of the paintings, now in the Ashmolean, is a

charming oil sketch of Bath Road with Esther and the four-year-old Orovida in the composition [cat. 2].

By October 1897, Lucien had recovered from his illness sufficiently to work again. He now turned his attention to his bookmaking. His book, *De la typographie et de l'harmonie de la page imprimée*, was a collaboration with Ricketts and production was started before his stroke in Epping in Davis's printshop, but after the stroke, Ricketts arranged for its completion at the Ballantyne press under his own supervision [cat. 14c].

Thereafter, all the Eragny Press books were produced in Lucien's home studio. Lucien not only designed his books but also produced and printed them. He was the only private press artist to attempt this. Neither Morris at the Kelmscott Press nor Ricketts at the Vale Press personally printed their own books. In part this may have been because of Lucien's chronic shortage of money, but perhaps more importantly, it reflected Lucien's belief in the paramount role of artist-craftsman which underpinned the philosophy of the Arts and Crafts movement. It is this integrity of the Eragny Press work which distinguishes the books from those of the other private presses, and which endows the books with their special charm.

In October 1897, Lucien had made sufficient progress to require a larger press which allowed him to produce his books entirely at home. He asked Camille for a loan to buy a press and, by September 1898, Camille had scraped enough funds together to be able to send 500 francs, and a press – a demi-sized Albion – was purchased and installed in Bath Road. Esther, herself, had been an art student at Crystal Palace School of Art, and from the beginning assisted in the production of work of the Eragny Press, making it difficult to disentangle their artistic contributions. Lucien, of course, was the finer painter, the theoretician and the designer, but Esther contributed energy and craftsmanship and worldliness. Initially, she did some of the simpler engraving, but after Lucien's stroke and the acquisition of the larger press in 1898, she took a greater role, taking charge of much of the printing and presswork. She became as technically proficient as Lucien. Together they were a formidable team, and the books of the Eragny Press are an expression of their collaborative efforts. Initially, the work was too strenuous for both and a printer was hired from the local printshop to assist periodically. In the next four years, seven books were produced by the Press, including the charming *Un coeur simple* [cat. 24].

In 1901, Esther and Lucien moved again, to a house on the Hammersmith/Chiswick boundary, less than 500 yards from their rented accommodation in Bath Road. The house was named The Brook, after Stamford Brook, which was a tributary of the Thames running just beside the house [fig. 11]. Esther called it her dream house, and indeed it must have reminded both Lucien and Esther of the French countryside. It was a completely dilapidated Georgian cottage, which had fallen into an advanced stage of disrepair. There was rotting wall covering, no functioning guttering and gaps in the roof. Water dripped into a rusty bath. It was buried in a wild and hopelessly overgrown garden, but with four old apple trees and a pear tree and three climbing vines. The house became the focus of Esther and Lucien's life and over the years they repaired and decorated it to become

Fig.10 | The sightlines of six paintings by Camille Pissarro, painted from 62, Bath Road shown on the 1894 Ordnance Survey map of Chiswick

The Brook

62 Bath Road

Stanford Brook Lodge

Stanford Brook House

Cottage and Glasshouses

what Tyrone Guthrie called 'the prettiest house in London.' Initially taken on a long lease with a repairing clause, the house was eventually bought by Esther and Lucien in 1919, and remains in the family. At times, the Pissarros were so short of money that they had to rent it out, sometimes living in Lucien's studio in the annex (one tenant was Alec Guinness). Brian Gould has left an evocative description of the house: 'the greater part of the interior is beautifully panelled in white or cream, the many mouldings accentuating pleasing irregularities of structure. Standing in the upstairs passage, I felt that I was in a smuggler's inn of the eighteenth century. Doors leant open like mysteriously unworded signposts.' Esther became an avid gardener and exchanged letters with Monet about the garden, which was planted in a French style. Whenever there was spare cash (which was rare) this was spent on the house. In the early days the house was surrounded by market gardens, but in the 1920s and 1930s as London advanced westwards, the area was rapidly built up, and the open countryside replaced by the ranks of closely packed suburban semis. However the house, and its garden, remained an oasis, as it still is. The central importance to Lucien and Esther of domestic life, of family and friends and particularly of the house and garden is clearly evident from the correspondence and from contemporary memoirs. This perhaps is one reason for the quiet and domestic nature of Lucien's art, both on paper and canvas, an art never public nor loud, but always peaceful and internal – one reason, also, for its enduring attraction.

The printing works were set up in the back room of the new house – a shed-like room with a large skylight, and Lucien's studio occupied the former stables at the front of the house. It was here that Lucien now designed his own typeface, which he named the 'Brook face.' This is a beautiful and delicate type. Colin Franklin has said that 'it is arguable that the Brook Type, on the white paper of the small pages of the Eragny books, was the most beautiful fount invented in this whole period.' The other two type faces which Lucien designed were made for Dr Jean François van Royen, an amateur printer of books at The Hague, who died in the Dutch resistance during the war. Van Royen wrote a touching description of a visit to The Brook in 1914: '… low, small, with four deep windows in which were are all kinds of flowers. On the walls paintings by Camille Pissarro, Lucien Pissarro and others. The dining room is even smaller. When you sit down there is no room left. On the walls old Japanese woodcuts, engravings by Durer, Ricketts and Pissarro. Above the fireplace are shelves of well-read books – apparently quite extraordinary books to judge by the title. Madam is very sweet, yet very cultured. Pissarro, hidden behind his beard and thick eyebrows, sat there enjoying everything so heartily and yet so quietly. He is an extremely sympathetic man. Refined and very clever; everything he says is well considered and exact and yet at the same time so simple and modest.'

Esther and Lucien were prolific letter-writers and many letters still exist to family and friends. The famous correspondence between Lucien and Camille is published and is a major documentary archive for the history of Impressionism, but many other letters exist between Esther and Lucien, their friends and other family which also allow the reconstruction of a picture of their lives. The Pissarros were 'at home' to their friends on every

M$^{R}_{\&}$ RS.

LUCIEN PISSARRO
AT HOME.
WED. DEC. 10th, 8 to 12
THE BROOK,
STAMFORD BROOK,
HAMMERSMITH. W.
R.S.V.P. (Music.)

Fig.11 | The Brook in 2010. Private collection

Fig.12 | *At Home.* Private collection.

other Sunday [fig. 12]. Tea and cakes were served, and then supper for those who stayed followed by music at the piano in the drawing room. On many occasions, Lucien would show his portfolios of Pissarro family drawings. Sometimes Orovida's Siamese cat would perch on Lucien's shoulder during the soirées. Many of the leading British artists attended these gentle occasions including T. M. Rooke, Francis Dodd, Spencer Gore, Harold Gilman, Robert Bevan and Walter Sickert. These salons became a major feature of home life in the period and the Pissarros had a network of close friends, many of whom were writers, artists or book illustrators. Among these, Diana White, whom Esther met when they were both art students at Crystal Palace Art School, was a lifelong confidante and a voluminous correspondent. Diana White also continued to draw and paint, and her views on art were regularly exchanged by letter with Esther and Orovida Pissarro, to whom she became a mentor and friend. Although her work is largely naturalistic, she urged Orovida to study Chinese art and Persian miniatures and to evolve away from Impressionism. The Eragny Press published one book written by Diana White, *The Descent of Ishtar* [cat. 35], partly illustrated with her own engravings. Archibald MacGregor, Esther and Diana White's teacher at Crystal Palace, and his wife Annie lived a few yards away from The Brook and remained close friends. MacGregor designed the refurbishment of the stables attached to The Brook in a charming Arts and Crafts style (so characteristic of the architecture of Bedford Park) and this was Lucien's studio. At times of financial difficulty, when The Brook was let, Esther and Lucien stayed with the MacGregors. Another very close friend living in the vicinity was Ethel Lilian Voynich, daughter of the famous mathematician George Boole, and wife of the Lithuanian exile, Wilfrid Michael Voynich. She was the author of *The Gadfly* (1897), a very popular novel, widely read in the labour movement, and also owner of the famous Voynich Manuscript now in Yale University Library. It was Ethel Voynich who usually played the piano at the 'at home' on Sunday evenings. She emigrated to New York, where she was visited by Esther in the very last months of Esther's life. It was through Voynich that Lucien was introduced to another life-long friend, James Bolivar Manson,

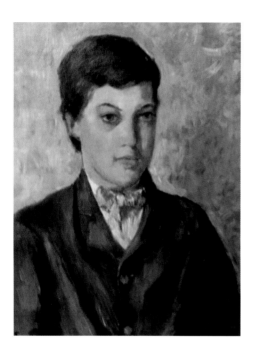
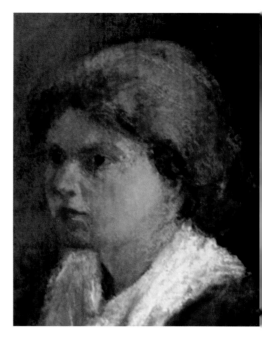

a fellow artist who joined the Tate Gallery as clerk in 1912. Manson became Director of the Tate in 1930 and there championed the work of the Impressionists and the artists of the New English Art Club. He was replaced by John Rothenstein, whose father, the artist William Rothenstein, was another of Lucien's close friends. Drawings of Lucien by Manson exist and the two families became very close. Manson encouraged Lucien to take an active part in the Fitzroy Street Group, the New English Art Club and to join the Camden Town Group which formed in 1919 with Manson as Secretary. Lucien and Manson formed the Monarro Group. During these years, Lucien became a bridge between English and French art, providing his colleagues with first-hand knowledge about Impressionism. As Sickert wrote in 1914: 'Pissarro, holding the exceptional position at once of an original talent, and of the pupil of his father, the authoritative depository of a man of inherited knowledge and experience, has certainly served us as a guide, or, let us say, a dictionary of theory and practice on the road we have elected to travel.' Another friend of Esther from her student days was Margaret Rust who had translated *The Queen of the Fishes*, the first book published by Lucien and Esther. Katherine Bradley and her niece and lover Edith Cooper were also friends of Ricketts and of Lucien living nearby in Richmond, (working under the pseudonym Michael Field). After Edith's death, Katherine Bradley commissioned Lucien's last book *Whym Chow* [cat. 48].

Lucien and Esther were thus, at their home in Chiswick, at the centre of an artistic web based both in London and in France. Lucien was a man universally liked, a man repeatedly described as being honest, gentle and wholly without artifice [fig. 13]. His shy and retiring nature, and his abhorrence of self-promotion were perhaps partly the reason for a relative lack of

Fig.13 | Camille Pissarro: *Portrait of Lucien Pissarro* (1874)

Fig.14 | Camille Pissarro: Portrait of Esther's sister, Ruth Bensusan-Butt (1893).

public commendation. He was usually silent, and as John Rewald remembers, a 'magnificent patriarch with dark, beautiful eyes, and a benevolent smile half-hidden beneath an imposing beard. Left to his own ingenuity – of which he had so little – he may have found it difficult to fend for himself', but he was supported throughout his life by Esther who fiercely protected and supported him. Lucien was dedicated to a life lived wholly as an artist, where art and life were made indivisible and where beauty and truth, underpinning art, were integrated with self and nature. He had no interest in the practicalities of money and the family frequently endured long periods of extreme poverty. He had often to rely on his father (who was also frequently without money) for gifts of small sums and on other friends and colleagues. Once, he had to borrow a substantial sum from Monet when he typically underestimated the costs of printing his books. Problems with money persisted throughout his life, and it was this poverty which perhaps restricted the production of the press and possibly dictated the small dimensions of the books and their limited number. If Lucien had had a financial backer, as Ricketts had, the output of the Eragny Press might have been much greater. As he wrote in 1910 to his mother: 'Had I not been so short of money I would have been able to produce another book, but I cannot make a book without spending money, and since I have only debts, I dare not increase them.' The idea of book-production as a business seemed inconceivable to Lucien – as he wrote to his nephew: 'Remember we don't work in order to earn our living, but because we cannot help it. If by chance you earn some money, all the better, but that is not the purpose.'

Esther was a very different personality. She was a headstrong woman, much like her red-headed sister Ruth [fig.14] and, although much loved by Lucien (and also by Camille), she clashed repeatedly with Julie. Esther was a gregarious and opinionated person, in character very unlike her gentle, quiet husband. It was she who organised the family and family life. Where Esther could interfere she did but, despite this, was adored by everyone. She was fiercely protective of Lucien throughout his life, just as Julie had been of Camille, and there is no doubt that the hopelessly impractical Lucien could not have survived as an artist, or in any other pursuit, without the support and assistance of his formidable wife. She had boundless energy, spent, as Rewald wrote, 'on two goals: to make friends happy, while at the same time running his [Lucien's] life by any means she could think of. Yet to say that she was domineering would not do her justice, for she meant well in everything she did. Her tremendous reservoir of good will simply would not allow her to draw a line between affection and possessiveness … Her vitality and confidence in the basic goodness of human beings knew no limits; thus she was unable to understand that her own motives could ever be questioned. And her motives were *always* excellent … She had no equal when it came to creating confusion, and she was so outspoken in her opinions that many found it difficult to get on with her. But at the same time, she never hesitated to give fully of herself, knew no bounds to her loyalty, and found in friendship a sacred means to assert her compassion. Her authoritarianism was alleviated by unreserved tenderness, a sentiment she often tried to hide, as if she were ashamed of it, although it was this

tenderness which made her so endearing. She was impractical, eccentric, obstinate, fussy, confused, and impatient, she was also her own and most persistent victim … She was as cheerful as she was disorganized and always stoically bore the consequences of her blunders. She was a warm human being with more faults – possibly – than others, but also with more fine qualities.' First and foremost, though, she was devoted to Lucien and committed her life and work to him.

Neither Esther nor Lucien had any business acumen and the press never made sufficient income to make either of them a proper living. The books and their print run were small and the prices unrealistically low. It has been argued that the lack of money was one factor in the small output of press, the lack of larger-scale projects and even the size and nature of the books. However, Lucien's artistic vision did not rely on finance. The press would not have been viable if Lucien and Esther had not carried out all the production work themselves, from the design and drawings through to the engraving and printing. They did so with meticulous care and the result are books whose whole existence and quality reflect Lucien's personal workmanship and ethic, artistically and technically.

The advent of war in 1914 resulted in the closure of the Eragny Press. Lucien could not obtain the paper and vellum for the books which had to be specially imported from France nor could he get ink from Germany and the commissions on which he had lately relied were no longer available. Thirty-two books had been produced but Lucien never returned to printing. For the rest of his life he focussed on painting and drawing and he turned away from the English style. His remaining work strictly adheres to the principles of Impressionism early instilled by his father, and the revolution in painting and graphic art that occurred in the early twentieth century entirely passed him by. Lucien died in 1944. In 1947, three years after his death, Esther and her nephew, John Bensusan-Butt, threw the Brook Type punches into the sea on a channel crossing, just as Ricketts had thrown the Vale Press punches into the Thames in 1903 and Cobden-Sanderson had cast the punches and matrices of the Doves type over Westminster Bridge in 1916. Many of the woodblocks, the preparatory drawings, and other studio material were given to the Ashmolean Museum by Esther, Orovida Pissarro and subsequently by other members of the family, where they now form a major part of the Pissarro Collection.

CATALOGUE 🍂

JON WHITELEY

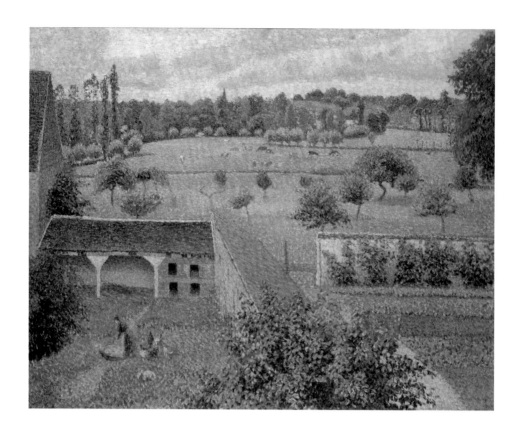

1 Camille Pissarro:
View from my Window

Oil on canvas 650 × 810 mm
Signed and dated: *C. Pissarro 1888.*

The view is taken from a window in the Pissarro house at Eragny-sur-Epte, a village near Gisors in Normandy where Camille and his family lived from 1884. Lucien named his press after the family home. 'Eragny' not only evoked a pastoral landscape of which Lucien had fond memories but it also referred, in the Pissarro family, to a kind of art which combined originality, naivety and the study of nature. The 'Eragny style', as Camille called it, contributed an important element to Lucien's work in England although, in the eyes of his father, it was often compromised by English sophistication. Eragny House was also the name which Lucien gave to the house in Epping where he lived with Esther from 1893 to 1897. This painting was begun by Camille in 1886 in the pointillist technique of small coloured dots associated with the work of his younger friend, Georges Seurat, and completed two years later. Lucien adopted a similar manner of painting between 1886 and the early 1890s.

Ashmolean Museum: presented by Esther Pissarro, 1950: A794: WA1950.184

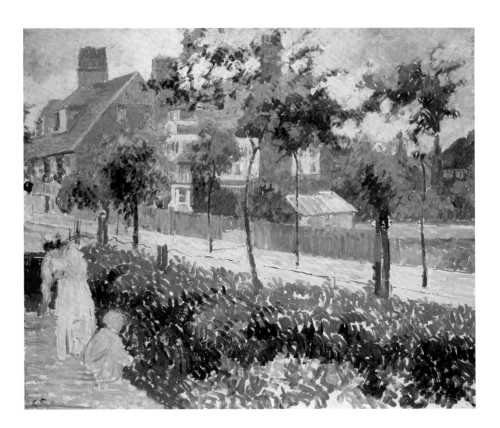

2 Camille Pissarro: *Bath Road*

Oil on canvas 540 × 650 mm
Stamped with initials: *C. P.*

In April 1897, Lucien moved with Esther and their daughter, Orovida, from Epping to no. 62 Bath Road in Bedford Park, a newly completed development in west London. Lucien had fallen ill before the move but had recovered by April. On 3 May, Esther Pissarro wrote to Camille to let him know that Lucien had been struck down again with what seems to have been a cerebral haemorrhage. Camille left immediately for England and remained at Bath Road from 7 May until 20 July while Lucien was recovering. During these months, Camille painted seven views from the house, including this unfinished sketch of the front garden. Esther is perhaps the figure on the left. Orovida, aged four, squats beside her.

Ashmolean Museum: Pissarro Family Gift, 1952: A825: WA1951.225.4

3 Camille Pissarro: *The Cricket Match*

Oil on canvas 540 × 650 mm
Signed and dated: *C. Pissarro. 97*

During the summer of 1897 when Camille was in London, he painted this view of a cricket match, seen from the terrace of his son's house in Bath Road. It has been suggested that the match was one played between Hammersmith and Shepherd's Bush Police and Traders on 27 June to celebrate Queen Victoria's Diamond Jubilee. Stamford Brook, where Lucien and Esther moved in 1902, lies beyond the trees. This painting, recently rediscovered, has not been exhibited since 1912.

Richard Green Gallery, London

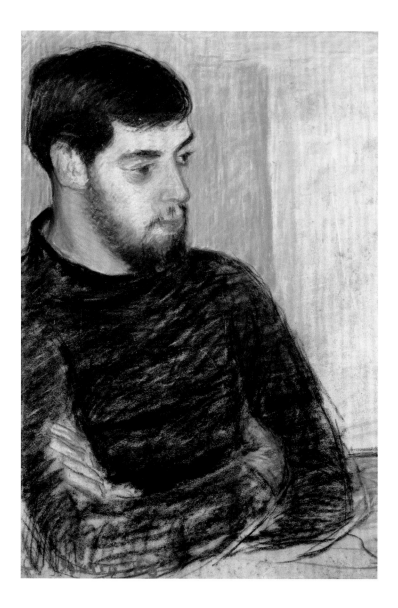

4 Camille Pissarro: *Portrait of Lucien*

Pastel 552 × 376 mm (sight)
Signed and dated: C. *Pissarro 83*

This portrait was drawn by Camille after
Lucien had returned from England to
spend the summer of 1883 with his family in
Osny. The Pissarros had moved to Osny in
December 1882. They remained there until
spring 1884 when they settled in Eragny.

Ashmolean Museum: B & L 157; W A 1952.6.208

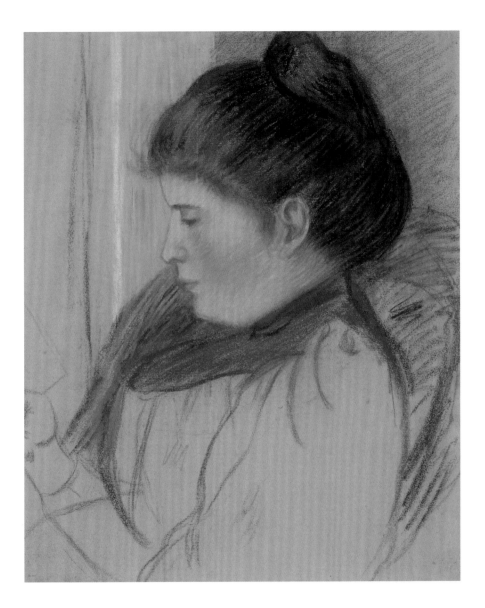

5 Lucien Pissarro: *Portrait of Esther*

Pastel on grey/green paper 444 × 375 mm

Lucien met Esther Bensusan in 1883 during the year he spent in England. He was introduced to her by his cousin, Esther Isaacson. Esther Bensusan was herself an artist with strong Socialist sympathies and found a congenial companion in Lucien. They were married at Richmond Registry Office in 1892 in the face of opposition from her father and his mother. His friends, Charles Ricketts and Charles Shannon, and his father were witnesses. Esther began by helping at the press with printing and cutting some of the lesser blocks but, after Lucien's stroke in 1897, she took a much greater role in the production of the books. This pastel must have been drawn shortly after their marriage. There is a similar portrait of Esther in The Ferens Art Gallery in Hull, dated 1893.

Ashmolean Museum: Pissarro Archive: 77.564

6 Family photographs

clockwise from right

[A] Camille painting at Bath Road

Pissarro Archive: OA.1681

[B] Lucien in his studio

[C] Lucien writing

[D] Esther and siblings

Private collection

[E] Esther Pissarro, Alice Isaacson, Lucien and Georges Pissarro pretending to be a train

Ashmolean Museum: Pissarro Archive: OA 1711

Apart from 6D, these photographs date from the time the Pissarros lived at Brook House, a seventeenth-century property, located at Stamford Brook, a short walk from Bath Road. They leased the house in 1902 and bought it in 1919. It was derelict when they moved in but, over the years, Lucien and Esther restored the building and established a flourishing garden. Lucien is shown here at work in one of the two rooms which housed the press.

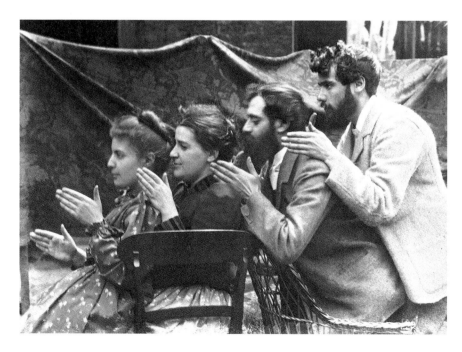

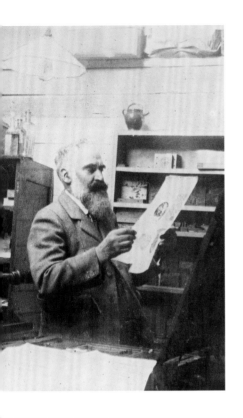

7 Two letters from Camille to Lucien

[A] Camille Pissarro to Lucien Pissarro, 26 November 1896 *not illustrated*

Camille had, at first, admired the art of Ricketts and liked him personally. By the end of 1896, however, Lucien's family had become alarmed at the extent to which the influence of Ricketts had altered Lucien's commitment to the 'Eragny style'. In November, Lucien defended himself against the charge that he had turned against his origins and fallen under the influence of what Camille described as the 'religiostic-anaemic' style of the English Pre-Raphaelites. In this reply, Camille reminded Lucien that his place was in France and that Ricketts was guilty of basing his art on the masters of the past in a manner which was 'diametrically opposed' to the principles of Impressionism.

[B] Camille Pissarro to Lucien Pissarro, 28 November 1896 *not illustrated*

Two days after the first letter, Camille wrote again to continue his criticism of Lucien's Pre-Raphaelitism. He accepted that Lucien's art was not religious or mystical but it had fallen into English sentimentality. Ricketts's idea of art was entirely based on the ancient Greeks. These criticisms were partly directed against *The Book of Ruth*. Camille greatly admired *The Queen of the Fishes* and used it over the years as a measure against which to judge Lucien's later work.

Ashmolean Museum: Pissarro Archive: OA.1667 and OA.1668

8 *L'aventure en sabot* [Adventure in a clog]

Pencil and watercolour 310 × 240 mm

In the late 1880s, Lucien made an uncertain livelihood by supplying illustrations to French journals and working in a chromolithographic studio. He also wrote and illustrated a number of children's books, none of which was published. This page is from a story of a girl who discovers a large wooden shoe and converts it into a boat. It has blank strips for the insertion of the printed text.

Ashmolean Museum: Pissarro Archive: 77.1557

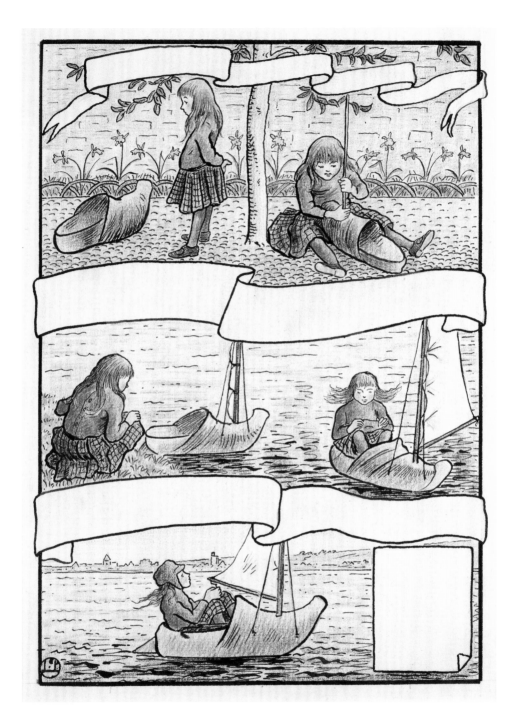

9 Twelve illustrations for *La Reine des poissons* [The Queen of the Fishes]

Pencil, pen and black ink and watercolour, each approximately 220 × 158 mm

In the late 1880s and early 90s, Lucien repeatedly attempted to interest publishers in France and in England in an illustrated edition of Gérard de Nerval's tale, *La Reine des poissons*. The text would have appealed to him, partly because it is a fairy tale set in the French countryside and partly because it is an ideal length for a short, illustrated children's book. Two versions, aimed at the English market, were turned down. This French version, completed in 1891, fared no better despite the debt to Walter Crane's popular sixpenny 'toy books' with their integrated text and image. The story with its abrupt, illogical changes and violent incidents is a tale which might nowadays seem ill-suited to young readers but to the children of Pissarro's generation, brought up on the often cruel tales published in the *Imagerie d'Épinal*, Nerval's odd story would have been familiar territory. It tells how a boy, sent to gather faggots by his uncle, a woodcutter, befriended a young girl while she fished for eels in a neighbouring stream. One day, the boy dreamt that the girl had been transformed into a fish and the girl dreamt that the boy had become a tree. As they spoke, the uncle approached and attacked the boy for wasting time with the girl and for refusing to break off branches to add to his faggots. While the woodcutter vented his rage on his nephew, the girl changed into a fish and would have been caught by the woodcutter in his trap had the boy not restrained him. The boy who, as he now discovered, was a Prince of the Forests, was rescued from his uncle's fury by a wind, summoned to his aid by the trees, which drove the woodcutter to his cabin. He returned with an axe, along with other woodcutters, and set about cutting down the trees. The girl, who was in reality the Queen of the Fishes, begged the rivers Marne, Oise and Aisne to intervene. They flooded the land and drowned the woodcutters. The Prince was transformed into a sylph and the Queen into a water nymph and in due course they were 'legitimately united'.

[A] Frontispiece

[B] The woodcutter's nephew with the fisher-girl

[C] The girl fishes for eels

[D] The children discuss their dreams

[E] The woodcutter threatens the boy

[F] The woodcutter catches the fish in his trap

[G] The uncle attacks the boy who becomes rooted to the ground

[H] The woodcutter is driven by a tempest to his cabin

[I] The woodcutters pull down the trees

[J] The Queen of the Fishes begs the rivers to intervene

[K] The forests release vapours which will supply the rivers with rain

[L] The Prince of the Forests and the Queen of the Fishes are reunited

Ashmolean Museum: Pissarro Archive: 77.1200–1211

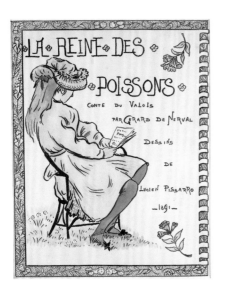

LA REINE DES POISSONS

CONTE DU VALOIS

PAR GÉRARD DE NERVAL

DESSINS DE

LUCIEN PISSARRO

—1891—

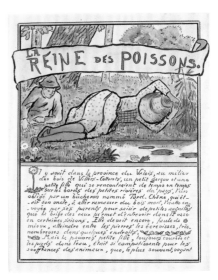

LA REINE DES POISSONS

Il y avait dans la province du Valois, au milieu des bois de Villers-Cotterets, un petit garçon et une petite fille qui se rencontraient de temps en temps sur les bords des petites rivières du pays, l'une obligé par un bucheron nommé Tord-Chêne, qui était son oncle, à aller ramasser du bois mort, l'autre envoyée par ses parents pour saisir de petites anguilles que la baisse des eaux permet d'enlever dans la vase en certaines saisons. Elle devait encore, faute de mieux, atteindre entre les pierres les écrevisses, très nombreuses dans quelques endroits. Mais la pauvre petite fille, toujours courbée les pieds dans l'eau, était si compatissante pour les souffrances des animaux, que, le plus souvent, voyant

les contorsions des poissons qu'elle tirait de la rivière, elle les y remettait et ne rapportait guère que les écrevisses, qui souvent lui pinçaient les doigts jusqu'au sang, et pour lesquelles elle devenait alors moins indulgente.

Le petit garçon, de son côté, faisant des fagots de bois mort et de bottes de bruyère, se voyait exposé souvent aux reproches de Tord-Chêne, soit parce qu'il n'en avait pas assez rapporté, soit parce qu'il était trop occupé à causer avec la petite pêcheuse.

Il y avait un certain jour dans la semaine où ces deux enfants ne se rencontraient jamais........ Quel était ce jour? Le même sans doute où la fée

Mélusine se changeait en poisson, et où les princesses de l'Edda se transformaient en cygnes. Le lendemain d'un de ces jours là, le petit bucheron dit à la pêcheuse : — Te souviens-tu qu'hier je t'ai vue, là-bas, dans les eaux de Challepont avec tous les poissons qui te faisait cortège........ jusqu'aux carpes et aux brochets; et tu étais toi-même un beau poisson rouge avec les côtés tout reluisants et écaillés d'or.

— Je m'en souviens bien, dit la petite fille, puisque je t'ai vu, toi, qui étais sur le bord de l'eau, et que tu ressemblais à un beau chêne vert dont les branches d'en haut étaient d'or..... et que tous les arbres du bois se courbaient jusqu'à terre en te saluant.

C'est vrai, dit le petit garçon, j'ai rêvé cela.

Et moi, j'ai rêvé ce que tu m'as dit, mais comment nous

sommes-nous rencontrés deux dans le rêve ?....

En ce moment, l'entretien fut interrompu par l'apparition de Tord-Chêne, qui frappa le petit avec un gros gourdin, en lui reprochant de n'avoir pas seulement lié encore un fagot. Et puis, ajouta-t-il, c'est ce que je ne t'ai pas recommandé de tordre les branches qui cèdent facilement, et de les ajouter tes fagots.

— C'est que, dit le petit, le garde me mettrait en prison, s'il trouvait dans mes fagots du bois vivant.... Et puis, quand j'ai voulu le faire, comme vous me l'aviez dit, j'entendais l'arbre qui se plaignait.

C'est comme moi, dit la petite fille, quand j'emporte des poissons dans mon panier, je les entends qui chantent si tristement, que je les rejette dans l'eau....

Alors on me bat chez nous.

— Tais-toi, petite masque! dit Tord-Chêne, qui paraissait animé par la boisson, tu déranges mon neveu de son travail. Je te connais bien, avec tes dents pointues couleur de perle.... Tu es la reine des poissons.... Mais je saurai bien te prendre à un certain jour de la semaine, et tu périras dans l'osier... dans l'osier!

Les menaces de Tord-Chêne, faites dans son ivresse, ne tardèrent pas à s'accomplir. La petite fille se trouva prise

sous la forme de poisson rouge, que le destin l'obligeait à prendre à certains jours. Heureusement, lorsque Tord-Chêne voulut, en se faisant aider de son neveu, tirer de l'eau la nasse d'osier, ce dernier reconnut le beau poisson rouge à écailles d'or qu'il avait vu en rêve, comme étant la transformation accidentelle de la petite pêcheuse.

Il osa la défendre contre

Tord-Chêne et le frappa même de sa galoche. Ce dernier furieux le prit par les cheveux, cherchant à le renverser; mais il s'étonna de trouver une grande résistance: c'est que l'enfant tenait des pieds à la terre avec tant de force, que son oncle ne pouvait venir à bout de le renverser ou de l'emporter; il le faisait en vain virer dans tous les sens. Au moment où la résistance de l'enfant allait se trouver vaincue, les arbres de la forêt frémirent d'un bruit sourd, les branches agitées laissèrent

...filtrer les vents, et la tempête fit reculer Tord-Chêne qui se retira dans sa cabane de bûcheron. Il en sortit bientôt, menaçant, terrible et transfiguré.

Comme un fils d'Odin, dans sa main brillait cette hache scandinave qui menace les arbres, pareille au marteau de Thor brisant les rochers.

Le jeune roi des forêts, victime de Tord-Chêne, savait déjà quel était son sort qu'on voulait lui cacher. L'ours très le protégeait, mais seulement par une résistance passive. En vain les broussailles et les sons fatals... sans s'inquiéter, inquiétante leurs...

pour arrêter les pas de Tord-Chêne, celui-ci a appelé ses bûcherons et trace un chemin à travers ces châteaux. Déjà plusieurs arbres, autrefois sacrés du temps des vieux druides, sont tombés sous les haches et les cognées.
Heureusement, la reine des poissons n'avait pas perdu de vue. Elle était allée se jeter aux pieds de la Marne, de l'Oise et de l'Aisne, les trois grandes rivières voisines, leur représentant que si l'on n'arrêtait pas les projets de Tord-Chêne et de ses compa-

gnons, les forêts trop éclaircies n'arrêteraient plus les vapeurs qui produisent les pluies et qui fournissent l'eau des ruisseaux, des rivières et aux étangs; que les sources elles-mêmes seraient taries et ne feraient plus jaillir l'eau nécessaire à alimenter les rivières; sans compter que tous les poissons se verraient détruits en peu de temps ainsi que les bêtes sauvages et les oiseaux.
Les trois grandes rivières prirent si bien ces avertissements que là où Tord-Chêne, avec ses terribles bûcherons, travaillait à la destruction des arbres, — sans toutefois avoir pu l'éteindre encore, le jeune prince des forêts fut entièrement noyé par une immense inondation, qui ne serait que après la destruction ci-dessus mentionnée des agresseurs.
Ce fut alors que le roi des forêts et la reine des poissons

purent de nouveau reprendre leurs innocents entretiens. Ce n'étaient plus un petit bûcheron et une petite poissonne, mais un Sylphe et une Ondine, lesquels, plus tard, furent unis légitimement.

FIN

10 *The First Portfolio*

In 1889, Lucien engraved three woodcuts on rustic themes close in subject and style to the second French version of *The Queen of the Fishes*: *Little May*, *Le Fagot* and *La Cueille des pommes*. A further nine, cut in the same heavily outlined manner, were made in 1891 and 1892. In May 1891 Lucien told his father that he intended publishing these in an album as a set of prints. All were based on drawings made in France and are filled with echoes of Eragny. Several are based on images designed for other publications. It is this which perhaps accounts for their lack of coherence as a series. The twelve prints were published in a portfolio by Ricketts and Shannon at the Vale in 1893.

La Cueille des Pommes [The Apple Harvest]

Five blocks: 162 × 129 mm

Ashmolean Museum: Pissarro Archive: 77.2174

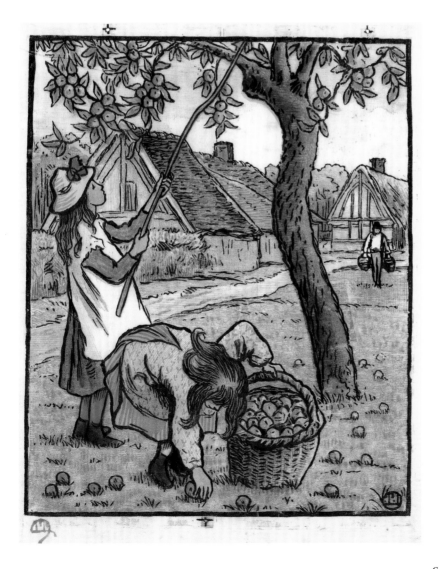

11 Two boxes of engraving tools

A collection of 36 engraving tools, including lozenge gravers, square gravers, spitstickers, round scorpers, square scorpers, tint tools, a medium bullsticker and chisels and dividers. These were made by Renart and Rubin in France and Buck, Stubbs, Sellers and Addis in England. They belonged to Lucien and were given by Esther to her nephew, Geoffrey Bensusan, after the war. Gravers and spitstickers were for cutting lines in the hard end-grain of the wood block; tint tools created effects of tone; scorpers and chisels removed the large, deeply cut sections.

Ashmolean Museum: WA 2008.75

12 *Travaux des champs* [Rustic Labour]

The *Travaux des champs*, a series of prints illustrating the work of the fields, is first mentioned in a letter from Camille to Lucien, dated 10 December 1886. This was planned as a book illustrated with prints by Lucien after Camille's drawings but, in common with all Lucien's early projects, it failed to find a publisher. Lucien continued to work on it after he had moved to England in 1890. In October 1891, he told his father that he was sure that Ricketts would take it up. Ricketts, however, persuaded Lucien to abandon the idea of a book in favour of a portfolio similar to Lucien's *First Portfolio*. This was completed in November 1894 and issued in 1895 with six woodcuts in line and colour: *Le Labour, Les Gardeuse de vaches, Etudes, La Femme aux poules, Les Sarcleuses,* and *Femme faisant de l'herbe*; six prints of a second series of seven were completed but never published; a third series was begun but abandoned. Lucien and Camille, however, remained convinced that there was a market for a book. Once Lucien had his own press, the idea became more feasible and Camille pressed him with increasing impatience for news of progress. In 1900, they made an arrangement with Benjamin Guinaudeau to provide them with a suitably bucolic text. Guinaudeau suggested three volumes of four poems each but Lucien preferred prose as his English and American clients would find that easier to read. There was a lack of focus in their discussions and the project came to nothing. Lucien, in any case, had other books in hand and did not wholeheartedly pursue the *Travaux*. Camille was disappointed not to see it among forthcoming Eragny publications in the final prospectus issued by the Vale Press. Lucien explained that this was no more than a list of the last works to be printed in Vale type but added that he would rather launch his Brook type with a classic like the *Fleurs du Mal* than with a new book like the *Travaux*

des champs. Camille's death on 12 November 1903 ended their collaboration. Early in the following year, Lucien began to think of publishing the drawings in an illustrated biography of his father. He published a prospectus for an ambitious series of six books, edited by his cousin, Georges Lecomte, each illustrated with an engraving *en camaieu* after a drawing by Camille but, after much searching for a sponsor, the idea was dropped and Lucien returned to the original plan of an illustrated book on rural life. This was finally published by the Eragny Press as *La Charrue d'érable* in 1913, twenty-seven years after the project was first mentioned in their letters.

[A] Five pearwood blocks for *Les Sarcleuses* [Women weeding]

Each approximately 230 × 160 × 23 mm
Line block: stamped *Kiessling J. Lacroix Paris 273* and inscribed *mardi* on verso
Yellow block: stamped *Kiessling J. Lacroix Succ. Paris* on verso; inscribed *Jaune* on recto
Pink block: stamped *Kiessling B. 273* on verso; inscribed *Rose* on recto
Blue block: stamped *Kiessling B.273* on verso; inscribed *Bleu* on recto
Red block: stamped *Kiessling B.273* on verso; inscribed *Rouge* on recto

These blocks were cut for *Les Sarcleuses*, a print of women weeding in a field, designed by Camille for the *Travaux des champs.* Camille's drawing was transferred by photography to the block. The outlines of the photograph can be seen in the areas where the blocks have not been cut. Kiessling and his successor J. Lacroix at 42 rue Descartes were Lucien's main source of woodblocks until *The Book of Ruth* when T. Lawrence of 4 West Harding Street in London became his chief supplier.

Ashmolean Museum: Pissarro Archive: 77.4226-4230

[B] *Les Sarcleuses*

Woodcut, five blocks: sheet: 258 × 176 mm; print: 177 × 120 mm

This print, designed by Camille Pissarro, was cut and printed by Lucien from a line block and four colour blocks. This is one of six prints from the *Travaux des champs*, published in a portfolio by Hacon and Ricketts at the Vale Press in 1894. On 23 September 1893, Camille sent a list of severe criticisms to Lucien concerning the final impression of *Les Sarcleuses*. He found the effect hard and the colours too strong. He wrote on the following day, modifying his criticisms: 'it is like a stained glass window and has a certain charm.'

Ashmolean Museum: Pissarro Archive: 77.1679

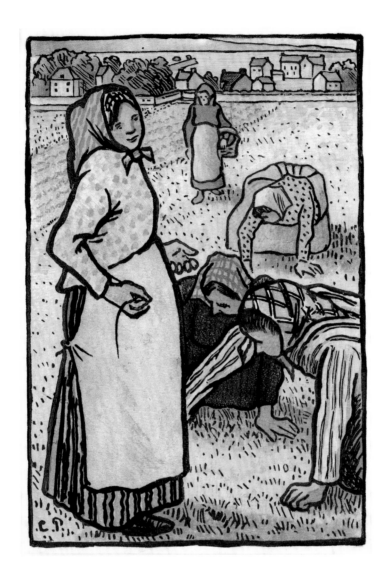

13 The Kelmscott Press

William Morris's Kelmscott Press, founded in Hammersmith in 1891, was the first of several private presses in Britain to apply the principles of the Arts and Crafts movement to making books. His most notable followers, including Lucien Pissarro, did not copy the appearance of the Kelmscott books but they were attracted by the idea of harmonising paper, type face, illustration and design to create an artistic unity. By 1898, Morris had published fifty-three books, using two type faces of his own design: Troy, based on fifteenth-century black letter, and Golden, based on Nicolaus Jenson's sixteenth-century type. He also used a smaller version of Troy, called Chaucer. Of the two main types, Lucien preferred Golden. Troy was too archaic for his taste.

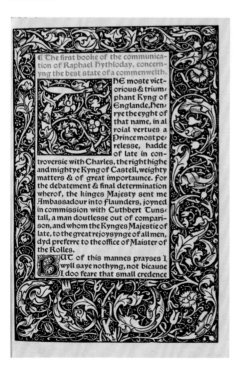

[A] Sir Thomas More: *Utopia*. Reprint of the second edition of Ralph Robinson's translation, edited by T. S. Ellis with a foreword by Morris: Kelmscott Press, 1893

More's *Utopia*, written in Latin in *c*.1515, was first published in an English translation in 1551. The text keenly interested Morris. His *News From Nowhere*, issued in 1893 is a 'Utopian Romance' partly inspired by More's image of an ideal society. In his preface, Morris emphasised More's contribution to modern Socialism. The text is set in Chaucer type, printed in black and red. The book is open at the last page of More's original introduction.

Lent by the Bodleian Library

[B] John Ruskin: *The Nature of Gothic. A Chapter of The Stones of Venice*: Kelmscott Press, 1892.

William Morris shared Ruskin's belief that society could be improved through art and that the highest form of art was to be found in Gothic architecture. Social reform through the reform of art led Morris towards Socialism. This book, which reprints a chapter from one of Ruskin's most influential works, is open at the last page of Morris's preface where Morris emphasises Ruskin's role in awakening hope for the creation of a new society. The scrolling border on the first page of text is a type imitated on occasion by Lucien.

Private collection

most enduring and beneficent effect on his contemporaries, and will have through them on succeeding generations. ❧ John Ruskin the critic of art has not only given the keenest pleasure to thousands of readers by his life-like descriptions, and the ingenuity and delicacy of his analysis of works of art, but he has let a flood of daylight into the cloud of sham-technical twaddle which was once the whole substance of "art-criticism," and is still its staple, and that is much. But it is far more that John Ruskin the teacher of morals and politics (I do not use this word in the newspaper sense), has done serious and solid work towards that new-birth of Society, without which genuine art, the expression of man's pleasure in his handiwork, must inevitably cease altogether, and with it the hopes of the happiness of mankind.

WILLIAM MORRIS,
Kelmscott House, Hammersmith.
Feb 15th, 1892.

THE NATURE OF GOTHIC.

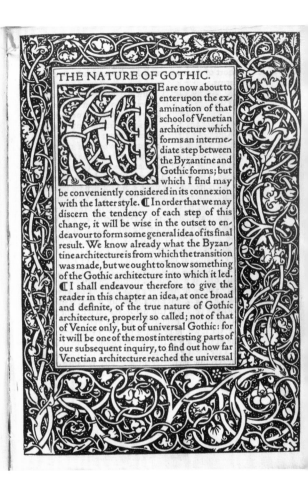

E are now about to enter upon the examination of that school of Venetian architecture which forms an intermediate step between the Byzantine and Gothic forms; but which I find may be conveniently considered in its connexion with the latter style. ❧ In order that we may discern the tendency of each step of this change, it will be wise in the outset to endeavour to form some general idea of its final result. We know already what the Byzantine architecture is from which the transition was made, but we ought to know something of the Gothic architecture into which it led. ❧ I shall endeavour therefore to give the reader in this chapter an idea, at once broad and definite, of the true nature of Gothic architecture, properly so called; not of that of Venice only, but of universal Gothic: for it will be one of the most interesting parts of our subsequent inquiry, to find out how far Venetian architecture reached the universal

14 The Vale Press

Charles de Sousy Ricketts was trained as a wood engraver. With Charles Shannon, he published an occasional magazine, *The Dial*, illustrated with engravings by his friends, which ran from 1889 to 1897. Lucien contributed to all but one of the five issues. Ricketts initially worked as a book designer for commercial publishers but planned to publish a series of books from ancient texts, designed and illustrated by himself with help from Shannon. *Daphnis and Chloe*, the first of only two books to appear in this projected series, was published in 1893. In 1896 an investment of £1,000 from a wealthy barrister, William Llewellyn Hacon, enabled him to set up his own publishing house named after The Vale, the house in Chelsea which he shared with Shannon. Unlike Lucien, he did not print his own books but had them printed at the Ballantyne Press, using type faces of his own design. Ricketts met Lucien in 1890, shortly after Lucien had arrived in England, and gave him generous support when he created the Eragny Press.

[A] *Daphnis and Chloe, a Most Sweet and Pleasant Pastoral Romance for Young Ladies, done into English by Geo. Thornley, Gent.* **Illustrated with woodcuts in the Italian manner by Charles Ricketts and Charles Shannon, 1893.** *illustrated right*

Ricketts was indebted to the principles of the Kelmscott Press but his books do not obviously resemble Morris's. The design is lighter and more elegant and the debt to Italian books of the Renaissance is more marked. *Daphnis and Chloe* is based on the late fifteenth-century *Hypnerotomachia Poliphili*, a book much admired for its harmonious union of text and illustration. The book is open at the illustration of the Wedding Feast in which, as Lucien informed Camille, 'all the people of the Vale are seated round the table, and I am with them in Greek guise'. C. J. Holmes is seated at the end of the table on the left: opposite him are five Vale artists, Ricketts, Shannon, T. Sturge Moore, Lucien, Reginald Savage and, standing behind, a certain Mr Riley, who was associated with the Press. Camille intensely disliked the 'Greek' tendency in contemporary English art and criticised Ricketts, in particular, for imitating the work of the past. He worried when he noticed echoes of English archaism in the work of his son.

Ashmolean Museum: OA.1669

[B] *De Cupidinis et Psyches amoribus fibula anilis:* **Landon, Hacon & Ricketts at the Vale Press, 1901.** *illustrated left*

Ricketts published William Ardlington's English translation of the tale in 1897. This later edition of Apuleius' original Latin, illustrated with woodcuts drawn and engraved by Ricketts, was edited by C. J. Holmes, Ricketts's manager, who dealt with the publication and distribution of the Eragny Books at the Vale Press.

Private collection.

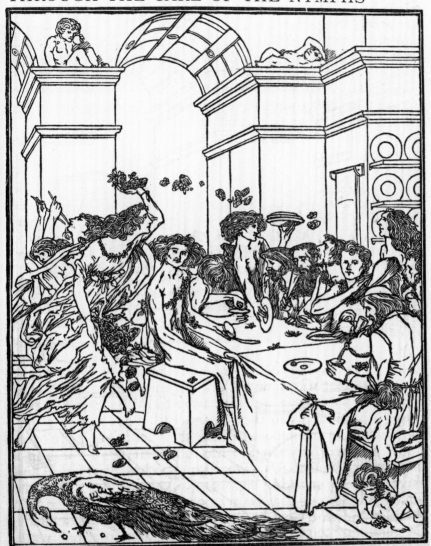

 MARRIED A WIFE, MY DEAR SONS,
when I was yet very young, and, after a while,
as I conjectured I should, it was my happi-
nesse to be a Father. For first I had a son
born, the second a daughter, and then Astylus
the third. I thought there was enow of the

breed

[c] C. Ricketts and L. Pissarro: *De la typographie et de l'harmonie de la page imprimée. William Morris et son influence sur les arts et métiers par Charles Ricketts & Lucien Pissarro;* mdcccxcviii. France en vente chez Floury, No. 1. Boulevard des Capucines, Paris. England sold by Hacon & Ricketts, LII. Warwick St., near Regents St., London. [On typography and the harmony of the printed page]

1 Opening pages

Following their first meeting in November 1890, Ricketts instructed Lucien in the importance of type face and its contribution to the harmonious appearance of the book. Both Ricketts and Lucien believed that type face should be based on the clearest ancient handwritten script to ensure legibility and that ornament and illustrations should not distract from but should contribute to the beauty of the whole. These principles, derived from William Morris, were set out in an essay published at the Vale Press in 1898 along with another on the influence of Morris on the Arts and Crafts movement. Lucien began some of the design work and printing on the essay but, because of his stroke, it was completed by Ricketts at the Ballantyne Press and published under the Vale imprint. It is not clear how the writing was divided between the two authors. The ideas it expresses are largely Ricketts's but their ideas on printing were closely shared and the manuscript, with corrections and changes by Georges Lecomte, now in the Ashmolean, is in Lucien's hand. It was written in French and intended to introduce ideas of English book design to the French market. As he told Floury, the French book-seller, it was printed without any ornament in order to show that typological design alone can ensure the beauty of a book.

Ashmolean Museum: Pissarro Archive: 77.3981

2 The Vale press mark

The same mark was used as the watermark in the Arnold's paper made for Ricketts and used by Lucien for the majority of the Eragny books printed with the Vale type.

Private collection

Il a été tiré de cet ouvrage 256 exemplaires, dont 6 sur parchemin.

DE LA TYPOGRAPHIE ET DE L'HARMONIE DE LA PAGE IMPRIMÉE.
WILLIAM MORRIS ET SON INFLUENCE SUR LES ARTS ET MÉTIERS
❧ PAR CHARLES RICKETTS & LUCIEN PISSARRO.

m
d
c
c
c
x
c
v
ii
i

FRANCE
EN VENTE chez Floury, No. I. Boulevard des Capucines, Paris.
ENGLAND
SOLD BY Hacon & Ricketts, LII. Warwick St., near Regent St., London.

3

15 Doves Press

Thomas Cobden-Sanderson entered the world of the private press through his bindery in Hammersmith where he took commissions from William Morris. In 1900, in collaboration with Morris's friend, Emery Walker, he set up the Doves Press next to the bindery and produced a sequence of books of extreme elegance and restraint. Unlike the Kelmscott books, the books published by the Doves Press were not illustrated and used a minimum of ornament. Cobden-Sanderson, however, remained true to the principles of the 'Book Beautiful' set out by Morris. He bound his books in vellum, like Morris, used the same Batchelor paper and a typeface, designed by himself, based on the Jenson type which had inspired Morris's Golden type. After the Press closed in 1916, Cobden-Sanderson threw the type into the Thames to prevent it from being reused.

John Milton: *Paradise regain'd: a poem in IV books: to which are added Samson Agonistes & Poems both English and Latin composed on several occasions*: Hammersmith, Doves Press 1905: printed in Doves type in black and red

Private collection

⟨ HERE BEGYNNYTH THE TREATYSE

OF FYSSHYNGE WYTH AN ANGLE

SALAMON IN HIS PARABLYS
sayth that a good spyryte makyth a
flourynge aege, that is a fayre aege &
a longe. And syth it is soo: I aske this
questyon, whiche ben the meanes & the causes
that enduce a man in to a mery spyryte: Truly
to my beste dyscrecion it semeth good dys-
portes & honest gamys in whom a man Ioyeth
without ony repentannce after. Thenne folow-
yth it that gode dysportes and honest games
ben cause of mannys fayr aege and longe life.
And therefore now woll I chose of foure good
disportes & honeste gamys, that is to wyte; of
huntynge: hawkynge: fysshynge: & foulynge.
The beste to my symple dyscrecion whyche is
fysshynge: callyd Anglynge wyth a rodde: &
a lyne and an hoke. And therof to treate as my
symple wytte may suffyce: both for the sayd
reason of Salamon and also for the reason that
phisyk makyth in this wyse. ⟨ Si tibi deficiant
medici medici tibi fiant: hec tria mens leta labor
et moderata dieta. ⟨ Ye shall understonde that
this is for to saye, Yf a man lacke leche or med-

3

16 Ashendene Press

Charles Henry St John Hornby founded a modest printing workshop in Ashendene in Hertfordshire in 1894. His ambitions were enlarged by a meeting with William Morris in 1895. In 1899 he moved the Ashendene Press to Chelsea where it became one of the finest of the small group of creative presses which emerged in the wake of Kelmscott. In 1900, Sydney Cockerell and Emery Walker persuaded Hornby to create his own 'Subiaco' type. This was designed for him by Cockerell and Walker on the basis of a fifteenth-century Italian model. Several of the books are illustrated but many rely solely on the beauty of the type and the *mise-en-page*. The press survived until 1915. It reopened in 1920 and did not close finally until 1935.

A Treatyse of Fysshynge with an angle by Dame Juliana Berners: Ashendene Press 1902

The text and frontispiece are taken from the original edition printed by Wynkyn de Worde in 1496. Little is known about Juliana Berners to whom the text is attributed.

Private collection

THE QVEEN OF THE FISHES·

&&&& Long ago, in the days when the
fairies were wont to prove the truth
of dreams to others besides the drea-
mers, a little woodcutter lay sleeping
on the bank of a river. The sun moved
round from East to West playing with
the shapes of the tree shadows on the
grass, driving them round from West
to East & from short to long, but the
boy slept on. And he knew his dream
for it was always the same. && He
thought he was a beautiful tree with

1

THE ERAGNY BOOKS

17 THE QUEEN OF THE FISHES. AN ADAPTATION IN ENGLISH OF A FAIRY TALE OF VALOIS. BY MARGARET RUST WITH ILLUSTRATIONS DESIGNED ON THE WOOD CUT AND PRINTED BY LUCIEN PISSARRO. PUBLISHED BY C. H. RICKETTS, 31 BEAUFORT ST, CHELSEA, LONDON. [1895]

Twelve woodcut illustrations, four in four colours, one in four colours with gold, seven in grey; four borders in green and one in gold; three ornaments in red: all designed and engraved on wood by Lucien Pissarro. Crown 8o. Colophon and press mark no. 1. Ten folded and five single leaves of Japanese handmade paper, printed on one side only. Text handwritten and reproduced by photographic process. 150 numbered copies of which 120 for sale at twenty shillings. Top edge gilt. Copies subscribed before publication bound in soft green leather with iris device stamped in gold upper right, the remainder bound in vellum similarly stamped.

After failing to interest publishers in an illustrated edition of Nerval's *La Reine des poissons*, Lucien decided to print the book himself. He used a version of Nerval's text, written in English by Esther's friend, Margaret Rust, who altered the original to make it more suitable for children. Lucien began work on the illustrations in 1893 and completed printing in February 1895, using a commercial firm near his home at Epping. As they did not have any type face of their own, Lucien wrote the text by hand and reproduced it from process blocks. The book was published by Charles Ricketts and marketed by John Lane at The Bodley Head. Thirty copies were bound in olive green calfskin for subscribers willing to pay the extra cost while the remainder were bound in vellum. This was the first book produced with the imprint of the Eragy Press.

[A] **Title page**

Private collection

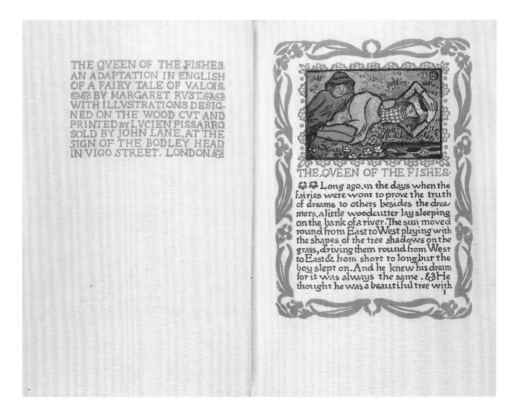

[B] Girl fishing for eels

Ashmolean Museum: Pissarro Archive: 77.3982

[C] Handwritten page of text

Because he had no type, Lucien wrote the text by hand and reproduced it by a photographic process on the page. This passage was written for page 4.

Ashmolean Museum: Pissarro Archive: OA.1670

[D] Binding

This vellum binding with two motifs is a variant of the standard binding which has a single gold iris stamped in upper right.

Private collection

[E] Colophon and Eragny Press mark no. 1

This version of the Eragny Press mark appears only in *The Queen of the Fishes*. It is monogrammed by Lucien in lower left and has Esther's initials in lower right.

Lent by the Bodleian Library

"VALE PUBLICATIONS."

ERAGNY PRESS

THIS BOOK HAS BEEN PRINTED IN 1894, BY LUCIEN PISSARRO AT HIS PRESS IN EPPING [ESSEX.]

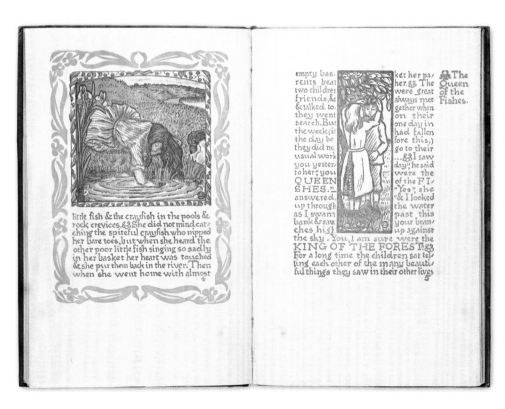

little fish & the crayfish in the pools & rock crevices. & She did not mind catching the spiteful crayfish who nipped her bare toes, but when she heard the other poor little fish singing so sadly in her basket her heart was touched & she put them back in the river. Then when she went home with almost

4

18 THE BOOK OF RUTH & THE BOOK OF ESTHER. WITH FIVE ILLUSTRATIONS DESIGNED AND CUT ON THE WOOD BY LUCIEN PISSARRO, PRINTED WITH HIS OWN HAND & ISSUED FROM HIS PRESS AT EPPING (ESSEX). [1896]

Fourteen initial letters and five illustrations designed by Lucien Pissarro and engraved on wood by Lucien and Esther Pissarro. Fifty-three leaves. Crown 12mo. Colophon but no press mark. 155 copies printed in Vale type in black and red on Arnold's handmade paper with the Vale watermark of which 150 for sale at fifteen shillings. Quarter bound in cream paper with title stamped in gold upper left; paper covered boards, printed with snowdrops, dark green on green.

Originally intended as an illustrated edition of the biblical story of Ruth and Booz, dedicated to his sister-in-law, Ruth Bensusan,

THE BOOK OF RUTH & THE BOOK OF ESTHER. WITH FIVE ILLUSTRA-TIONS DESIGNED AND CUT ON THE WOOD BY LUCIEN PISSARRO, PRINTED WITH HIS OWN HAND & ISSUED FROM HIS PRESS AT EPPING (ESSEX).

THE BOOK OF RUTH. CHAPTER THE FIRST.

i Elimelech driven by famine into Moab, dieth there. iv Mahlon and Chilion, having married wives of Moab, die also. vi Naomi returning homeward, viii dissuadeth her two daughters in law from going with her. xiv Orpah leaveth her, but Ruth with great constancy accompanieth her. xix They two come to Bethlehem, where they are gladly received.

OW it came to pass in the days when the judges ruled, that there was a famine in the land. And a certain man of Beth-lehem-judah went to sojourn in the country of Moab, he, and his wife & his two sons.

i a And

Lucien extended the text by adding the story of Esther and included his wife, Esther Bensusan, in the dedication. Lucien at first thought of writing the text by hand, as he had done in *The Queen of the Fishes*, but came to an arrangement with Ricketts which allowed him to use the Vale type. Ricketts supplied his type on condition that all books printed with it should be published by him. *The Book of Ruth* was the second book produced at the Eragny Press and the first of fifteen printed using the Vale type.

[A] title page

Private collection

[B] Ruth Gleaneth

This copy is inscribed by Lucien to his father

Private collection

[C] *Coronation of Esther*

This copy is inscribed by Orovida Pissarro to David Bensusan-Butt

Private collection

[D] Binding

The Book of Ruth was the first of many Eragny books to be bound in card faced with a paper printed in a floral pattern. The papers were designed by Lucien. He designed a similar range of cover papers for the Vale Press. This was cheaper than the vellum and calfskin used for *The Queen of the Fishes* and it left the owner with the option of providing a more expensive binding. Lucien, himself, had several of his own books professionally rebound.

Ashmolean Museum: Pissarro Archive: 77.3983

Go not to glean in another field, neither go from hence, but abide here fast by my maidens: IX Let thine eyes be on the field that they do reap, & go thou after them: have I not charged the

x young

ing diverse one from another,)and royal wine in abundance, according to the state of the king. VIII And the drinking was according to the law; none did compel: for so the king had appointed

xxx to

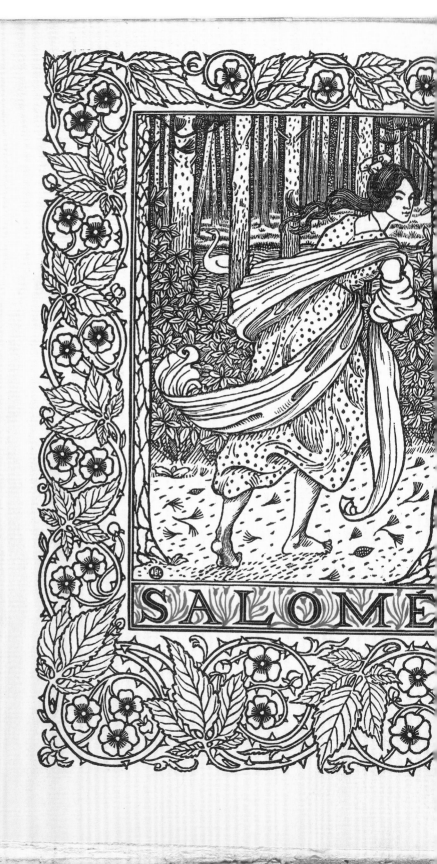

SALOMÉ

SALOME.

Naître, c'est sortir; mourir, c'est rentrer.
(Proverbes du royaume d'Annam recueillis
par le P. Jourdain, des Missions Etrangères.)

I

IL faisait ce jour-là deux mille canicules qu'une simple révolution rythmique des Mandarins du Palais avait porté le premier Tétrarque, infime proconsul romain, sur ce trône, dès lors héréditaire par sélection surveillée, des Iles Blanches ésotériques, dès lors perdues pour l'histoire, gardé toutefois cet unique titre de Tétrarque, qui sonnait aussi inviolablement que Monarque, outre les sept symbolismes d'état attachés à la désinence "tetra" contre celle de "monos". En trois pâtés aux pylônes trapus et nus, cours intérieures, galeries, canaux, et le fameux parc suspendu avec ses jungles viridant aux brises atlantiques, & l'observatoire ayant l'œil en vigie à deux cents mètres chez le ciel, et cent rampes de sphinx et de cynocéphales: le palais tétrarchique n'était qu'un monolithe, dégrossi, cavé, évidé, aménagé et finalement poli

19 JULES LAFORGUE.
MORALITES LEGENDAIRES. TOME PREMIER [1897]

[Jules Laforgue: Moral Tales. Volume one]

Frontispiece, double border, black and red, and nine initials designed by Lucien Pissarro and engraved on wood by Lucien and Esther Pissarro. Colophon, but no press mark. Sixty-two leaves. Small demy octavo. 220 copies printed in Vale type on handmade paper of which 200 for sale at sixteen shillings: watermark: O D & S. Top edge gilt. Quarter bound in grey paper, title stamped in gold upper left and on the spine; paper covered boards, printed with wood sorrel, green on white.

After launching his press with two works in English, Lucien had ambitions to market his books in France. His third book, volume one of Jules Laforgue's *Moralités légendaires*, was aimed at French collectors. He sent the frontispiece to exhibitions of books at Vollard's gallery and Bing's gallery in Paris in summer 1896 and completed the remainder of the book in December. Publication was delayed as agreement had to be negotiated with Laforgue's brother who held the copyright and with the *Mercure de France* which agreed to sell the book on commission. One hundred copies were reserved for the *Mercure de France*, seventy-six went to Hacon and Ricketts and the remainder was distributed to friends and family. Lucien's stroke in May hampered progress on the second volume which was not published until March 1899. Both volumes were printed in red and black with a handsome frontispiece, framed within elaborate foliate borders inspired by Morris.

[A] Frontispiece: *Salomé*

The frontispiece illustrates the tale of Salomé and John the Baptist, the first of three stories in this volume. Laforgue's ornate use of words and mocking tone would appealed to the writers and artists in the circle of Ricketts's Vale Press and John Lane's Yellow Book. His retelling of the story of Salomé parodies a favourite theme in Symbolist art and literature. She is shown here walking through the park of pine trees 'hermetically wrapped in a cobweb of jonquil chiffon decorated with black spots', as Laforgue describes her in his ironically convoluted prose. Lucien reused the ornate Pre-Raphaelite border in both his books of Perrault's tales. This copy has a dedication from Lucien to his father.

Ashmolean Museum: Pissarro Archive 77.3884

[B] Lucien Pissarro: *Salomé*

Pen and brown ink

Private collection

[C] Binding

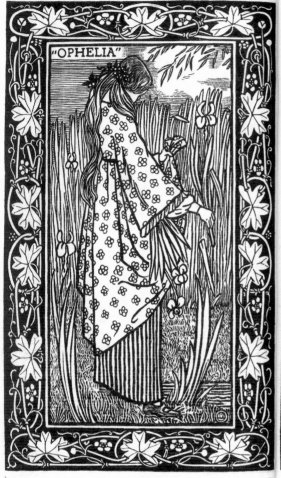

"OPHELIA"

HAMLET ou les suites de la piété filiale. C'est plus fort que moi.

DESAFENEtre préférée, si chevrotante à s'ouvrir avec ses grêles vitres jaunes losangées de mailles de plomb, Hamlet, personnage étrange, pouvait, quand ça le prenait, faire des ronds dans l'eau, dans l'eau, autant dire dans le ciel. Voilà quel fut le point de départ de ses médiations et de ses aberrations. La tour où, depuis l'irrégulier décès de son père, le jeune prince s'est décidément arrangé pour vivre, se dresse en lépreuse sentinelle oubliée, au bout du parc royal, au bord de la mer qui est à tous. Ce coin de parc est le cloaque où l'on

[Jules Laforgue: Moral Tales. Volume two]

Frontispiece, double border, black and red, and
five initials designed by Lucien Pissarro and
engraved on wood by Lucien and Esther Pissarro.
Crown octavo. Colophon and press mark no. 2.
Seventy leaves. 220 copies printed in Vale type on
French paper of which 200 for sale at twenty shil-
lings: watermark: OD&S. Top edge gilt. Quarter
bound in grey paper, title stamped in gold upper
left and on the spine; paper covered boards,
printed with wood sorrel, green on white. Four
copies printed on vellum not for sale

[A] **Frontispiece:** *Ophelia*

The frontispiece of Ophelia standing by the
brook was drawn by Lucien but engraved
by Esther as Lucien was too weak after his
stroke to undertake the work.

Private collection

[B] **Press mark no. 2**

This press mark appeared for the first time
in volume two of the *Moralités légendaires*.
It was used once more in the volume of
Perrault's tales published in 1899 but was
withdrawn after the publishers, Elkin
Mathews, complained that the motto
Fructus inter folio had been used in their
books for many years.

Ashmolean Museum: Pissarro Archive: OA.1682

VALE PUBLICATIONS.
LISTE DES LIVRES ORNES ET IM-
PRIMES PAR LUCIEN PISSARRO;
SUIVIE DE CELLE DES PORTE-
FEUILLES de GRAVURES SUR BOIS
AU TRAIT ET EN COULEURS.

Fait aux Presses d'Eragny le Ier. Février
M.DCCC.XCVIII.

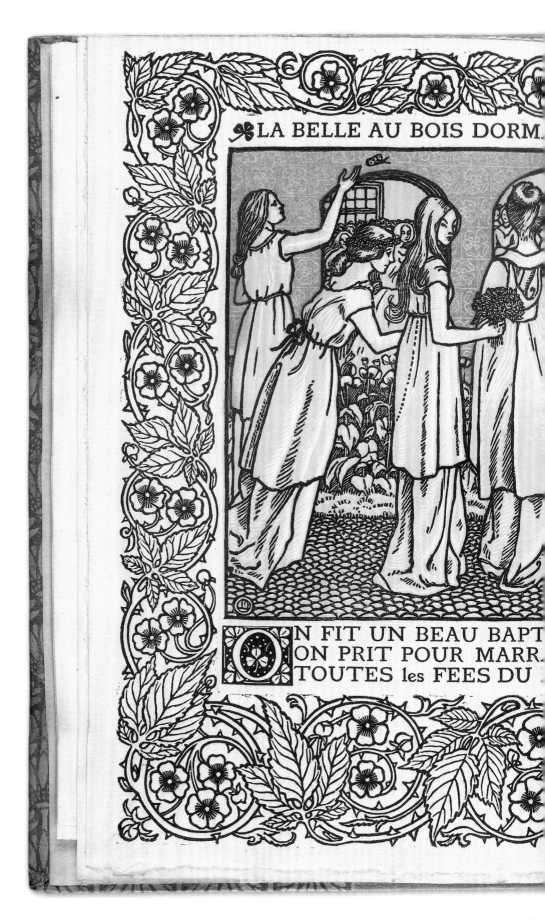

LA BELLE AU BOIS DORM.

ON FIT UN BEAU BAPT
ON PRIT POUR MARR.
TOUTES les FEES DU

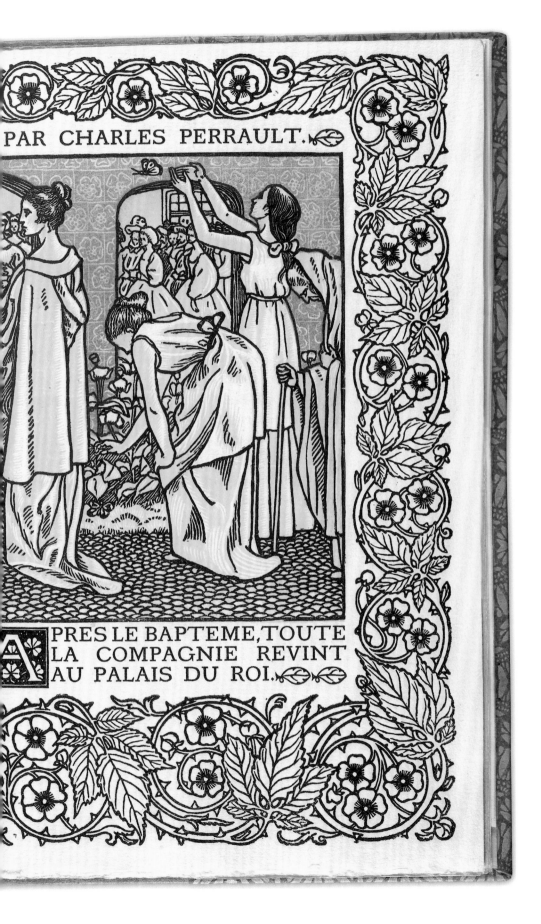

APRES LE BAPTEME, TOUTE LA COMPAGNIE REVINT AU PALAIS DU ROI.

21 LA BELLE AU BOIS DORMANT & LE PETIT CHAPERON ROUGE. DEUX CONTES DE MA MERE LOYE PAR C. PERRAULT DE L'ACADEMIE FRANÇAISE. M.DCCC.XCIX. [1899]

[Charles Perrault: Sleeping Beauty and Little Red Riding Hood]

Title with roundel, frontispiece on two pages in grey/green, gold and black, a double border, one further illustration, thirty-five small initials and two large initials designed by Lucien Pissarro and engraved on wood by Lucien and Esther Pissarro. Small demy octavo. Colophon and press mark no. 2. Twenty-six leaves. 220 paper copies printed in Vale type on Arnold's unbleached handmade paper with the Vale watermark of which 200 for sale at twenty shillings. Quarter bound in blue/grey paper, title stamped in gold upper left; paper covered boards printed with lotus flowers, blue on white. Four copies printed on vellum not for sale.

Perrault's fairy stories were a natural transition from *The Queen of the Fishes*. In a letter to Camille, dated 4 December 1895, Lucien mentioned that he was intending to publish Perrault's stories with an engraving in colour. He had completed the drawings for the illustrations before his stroke in May 1897 but, on account of his illness, these were engraved by Esther. The book was published in July 1899.

[A] Title page

The geese were based on a drawing made by Lucien in Epping. Camille was delighted with the image. It struck him as a perfect balance between Lucien's decorative ideal and his own preference for greater naturalism.

Ashmolean Museum: Pissarro Archive: 77. 3987

[B] *The Baptism*: illustration to *Sleeping Beauty*

The seven fairies invited to the feast and the old fairy on the left who was overlooked are arranged in a symmetrical frieze somewhat reminiscent of Burne-Jones's work at this time. In a letter of 23 January 1896, referring to his proposal to illustrate the Mother Goose stories with a colour engraving, he mentions his enthusiasm for the Italian chiaroscuro prints which he had just seen in the British Museum. These probably inspired the refined colour scheme of black, grey and gold used in the printing. Lucien's sister-in-law, Ruth Bensusan, was the model for the fairies. The border was first used in volume one of Laforgue's *Moralités légendaires*.

Private collection

[c] *Little Red Riding Hood*

The second illustration in the Mother Goose stories was based on a watercolour of the Queen of the Fishes kneeling before the Three Rivers, made for the early French version of Nerval's tale. He had already used it in a wood engraving published in *The Dial* in March 1896. There is a certain debt to the similar illustration in Walter Crane's *Little Red Riding Hood*, published in 1875. The rustic naivety of the image with its echoes of his early work contrasts with the Pre-Raphaelite character of *The Baptism*.

This copy is inscribed by Lucien and Esther to Esther's sister, Ruth Bensusan.

Private collection

[d] **Binding: white vellum with silk ties, stamped with title in gold, upper left**

One of four copies of the Mother Goose stories printed and bound in vellum. The silk ties were once coloured but have now faded. Lucien blamed a fault in the manufacture for their tendency to crumple.

Ashmolean Museum: Pissarro Archive: 77.3986

22 LES BALLADES DE MAISTRE FRANCOIS VILLON. LONDON HACON & RICKETTS 17 CRAVEN STREET STRAND. MCM [1900]

[The Ballads of François Villon]

Frontispiece designed and engraved on wood by Lucien Pissarro. Border, twenty large initials and sixteen small initials designed by Lucien Pissarro and engraved on wood by Lucien and Esther Pissarro. Printed throughout in black and red in Vale type. Crown octavo. Colophon and press mark no. 3. Fifty leaves. 226 copies printed on Arnold's unbleached handmade paper with the Vale watermark, of which 200 for sale at twenty-five shillings. Top edge stained green. Quarter bound in buff paper, title stamped in gold upper left and on the spine; paper covered boards, printed with rosettes, pink on white. Four copies printed on old Japanese handmade paper not for sale.

On 9 September 1896, Lucien asked his father to send him an edition of Villon's works as he was considering publishing a text by him. In the following March, he asked his father to make enquiries in Paris about a possible rival edition of Villon illustrated by Emile Gérardin. Camille wrote back to say it that it was 'atrocious' and no competition for Lucien's planned book. Printing difficulties delayed publication and the book did not appear until the summer of 1900

[A] **Title and first page**

All the pages, including the frontispiece, were printed in black and red. This made registration difficult as the damp paper tended to distort between printing one colour and another. Lucien hired a printer to help speed up the process. This is one of four copies printed on Japanese handmade paper.

Ashmolean Museum: Pissarro Archive: 77.3988

[B] **Binding**

The cover, as issued, was printed in pink. The Ashmolean copy is covered with green on white.

Private collection

LES
BALLADES
DE
MAISTRE FRANCOIS VILLON.

LONDON
HACON & RICKETTS
17 CRAVEN STREET STRAND.
 MCM

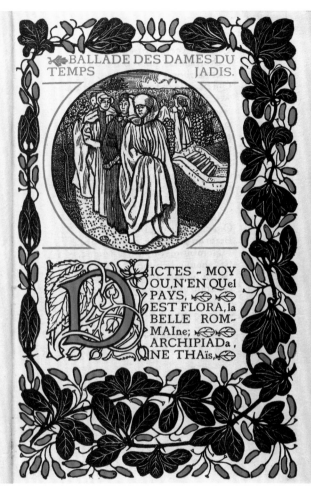

BALLADE DES DAMES DU TEMPS JADIS.

DICTES ~ MOY OU, N'EN QUel PAYS, EST FLORA, la BELLE ROM~ MAIne; ARCHIPIADa, NE THAïs,

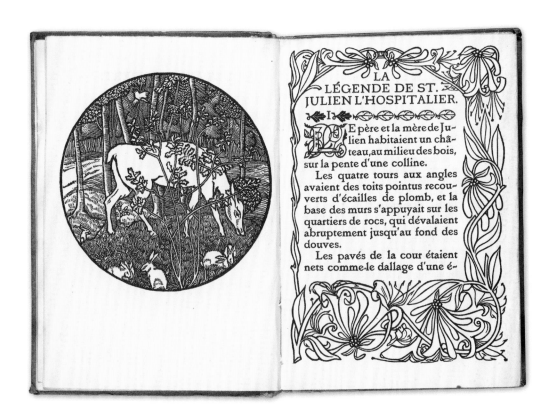

23 GUSTAVE FLAUBERT.
LA LÉGENDE DE SAINT JULIEN
L'HOSPITALIER [1900]

[Gustave Flaubert: The legend of St Julian the Hospitaller]

Frontispiece designed and engraved on wood by Lucien Pissarro. Border, one small initial and two large initials designed by Lucien Pissarro and engraved on wood by Lucien and Esther Pissarro. Vale type. Demy 16mo. Colophon and press mark no. 3. Fifty-three leaves. 226 copies printed on Arnold's unbleached handmade paper with the Vale watermark of which 200 sold at fifteen shillings. Quarter bound in buff cloth, title on a label upper left; blue paper boards.

In February 1896, while approving the idea of reprinting Laforgue, Camille suggested that his son should think of Flaubert whose works were not in copyright. In December, while Lucien was attempting with difficulty to negotiate the rights to Laforgue, he pointed out again that Flaubert's works would cost him nothing. In 1900–1, Lucien printed three short stories by Flaubert in a row, in a uniform binding, covered with blue paper like the Kelmscott books, and ornamented with a frontispiece within a border of honeysuckle.

[A] Frontispiece

Lucien engraved the image of the deer twice. He recut it because he found the first version too dark. In the second version he added rabbits in the foreground and lightened the background.

Ashmolean Museum: Pissarro Archive: 77.3990

[B] Binding: [With image for 24 & 25]

Private collection

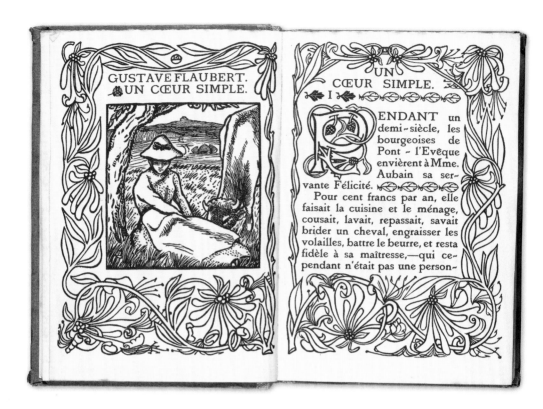

24 GUSTAVE FLAUBERT. UN COEUR SIMPLE. [1901]

[Gustave Flaubert: A Simple Heart]

Frontispiece designed and engraved on wood by Lucien Pissarro. Border, one large initial and two small initials designed by Lucien Pissarro and engraved on wood by Lucien and Esther Pissarro. Vale type. Vale watermark. Demy 16mo. Colophon and press mark no. 3. Sixty-three leaves. 226 copies printed on Arnold's unbleached handmade paper with the Vale watermark of which 200 sold at fifteen shillings. Quarter bound in buff cloth, title on a label upper left; blue paper boards.

[A] **Frontispiece**

The pastoral subject encouraged Lucien to look back to his early years in Eragny. At first he asked his father to supply him with an appropriate image but Camille refused. Lucien, instead, drew a variant of a drawing dating from 1884 adapted to represent the simple peasant girl of the title. His father liked the result while finding faults in the drawing of the cow and pointing out that the girl's arm seemed truncated.

Ashmolean Museum: Pissarro Archive: 77.3391

[B] **Binding [With image for 23 & 25]**

Private collection

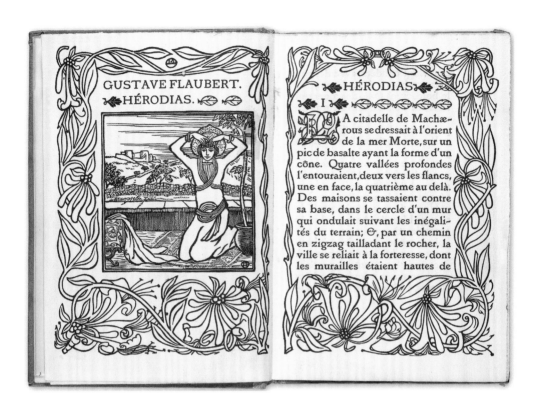

25 GUSTAVE FLAUBERT. HÉRODIAS. [1901]

Frontispiece designed and engraved on wood by Lucien Pissarro. Border and two small initials designed by Lucien Pissarro and engraved on wood by Lucien and Esther Pissarro. Vale type. Demy 16mo. Colophon and press mark no. 3. Fifty-eight leaves. 226 copies printed on Arnold's unbleached handmade paper with the Vale watermark of which 200 for sale at fifteen shillings. Quarter bound in buff cloth, title on a label upper left; blue paper boards.

[A] **Frontispiece**

Lucien sent his father two different ideas for the frontispiece, one drawn in the manner of his illustrations for *The Book of Ruth*, the other more stylised and more simple. Camille liked them both but recommended the single figure because it was less complicated than the other. Lucien followed his advice.

Ashmolean Museum: Pissarro Archive: 77.3992

[B] **Binding [With image for 23 & 24]**

Private collection

26 AUTRES POESIES DE MAISTRE
FRANÇOIS VILLON & DE SON ECOLE.
LONDON HACON & RICKETTS 17
CRAVEN STREET STRAND. MCMI
[1901]

[Other Poems by François Villon, and
by his followers]

Frontispiece designed and engraved on wood by
Lucien Pissarro. Border, nine large initials, fifteen
medium sized initials and three small initials
designed by Lucien Pissarro and engraved on
wood by Lucien and Esther Pissarro. Printed
throughout in black and red, borders in green.
Vale type. Crown octavo. Colophon and press
mark no. 3. Thirty-six leaves. 226 copies printed
on Arnold's unbleached handmade paper with the
Vale watermark of which 200 for sale at twenty-
five shillings. Top edge stained green. Quarter
bound in buff paper, title stamped in gold upper
left and on the spine; paper covered boards,
printed with rosettes, green on white. Four copies
printed on old Japanese handmade paper not for
sale.

[A] **Frontispiece and first page**

Camille admired the frontispiece but
noted that the figure looked more like a
peasant than the old courtesan of Villon's
text. He also thought that the costume was
too modern. Lucien, in reply, explained
that his model had been a puritanical
Protestant who would have been surprised
to know that she had been cast in the role
of a courtesan. Lucien reused the border
designed for his first volume of Villon but
printed it in pale green without the added
red. Printing the berries in one colour would
have required plugging the voids on the
berries in the block. This copy on Japanese
paper has a dedication from Lucien to his
father.

Ashmolean Museum: Pissarro Archive: 77.3989

[B] **Binding** *not illustrated*

The binding matches the binding on the
companion volume of Villon's poems
published the previous year.

Private collection

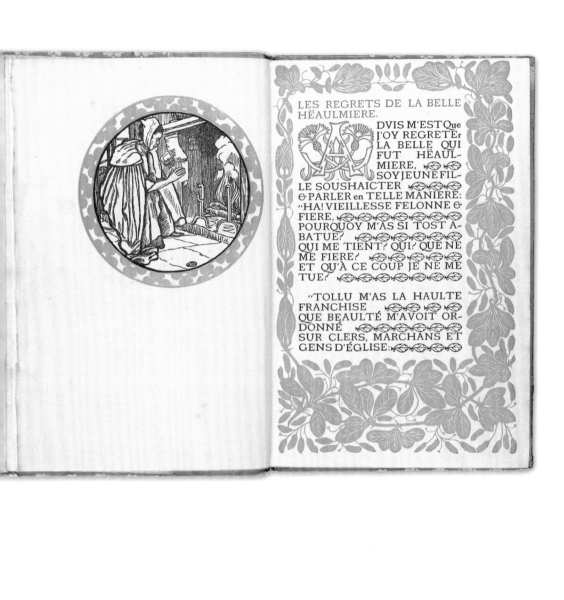

LES REGRETS DE LA BELLE HÉAULMIERE.

ADVIS M'EST Que J'OY REGRETEr LA BELLE QUI FUT HÉAULMIERE, SOY JEUNE FILLE SOUSHAICTER & PARLER en TELLE MANIERE: "HA! VIEILLESSE FELONNE & FIERE, POURQUOY M'AS SI TOST ABATUE? QUI ME TIENT? QUI? QUE NE ME FIERE? ET QU'À CE COUP JE NE ME TUE?

"TOLLU M'AS LA HAULTE FRANCHISE QUE BEAULTÉ M'AVOIT ORDONNÉ SUR CLERS, MARCHANS ET GENS D'ÉGLISE:

27 Emile Verhaeren. LES PETITS VIEUX.
London, Hacon & Ricketts
17 Craven Street, Strand. W [1901]
[Emile Verhaeren: The Little Old
Willow Trees]

Frontispiece in five colours designed and engraved on wood by Lucien Pissarro. Thirteen initials in red and one in red and green designed by Lucien Pissarro and engraved on wood by Lucien and Esther Pissarro. Printed throughout in black and red in Vale type. Small oblong indeterminate format. Colophon and press mark no. 3. Two single leaves and eleven folded, printed on one side. 230 copies printed on Japanese handmade paper. 200 for sale at twenty shillings. Top edge gilt. Quarter bound in grey paper, title stamped in gold on the spine; paper covered boards, printed with winter aconites, green and yellow on French grey.

The Belgian poet, Verhaeren, had been a friend of Camille's since 1887 and shared the Pissarros' anarchist sympathies. Once again, Lucien turned back to one of his discarded illustrations from the French version of *The Queen of the Fishes* for a suitable rustic image

[9H]. The frontispiece was engraved by Lucien and printed in five colours. Lucien felt that it represented a high point in his mastery of the printing process but Camille detested it, preferring the flawed charm of Lucien's early work to the apparently uninspired competence of this print.

[A] Frontispiece

The image of elderly lovers makes use of the figure of the wicked uncle returning to his cottage in one of the early designs for *The Queen of the Fishes*.

Private collection

[B] Pages 4 and 5

The book was printed in red and black throughout. The small oblong format suited the lines of Verhaeren's short verses.

Ashmolean Museum: Pissarro Archive: 77.3993

[C] Binding paper with a printed pattern of winter aconites *illustrated on page 8*

Ashmolean Museum: Pissarro Archive: OA.1672

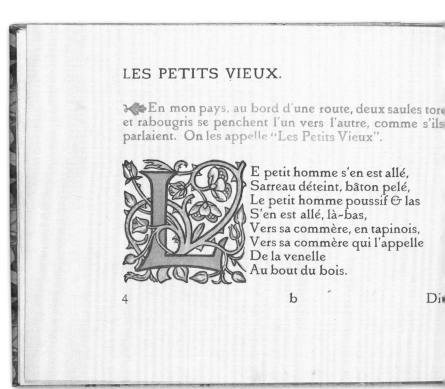

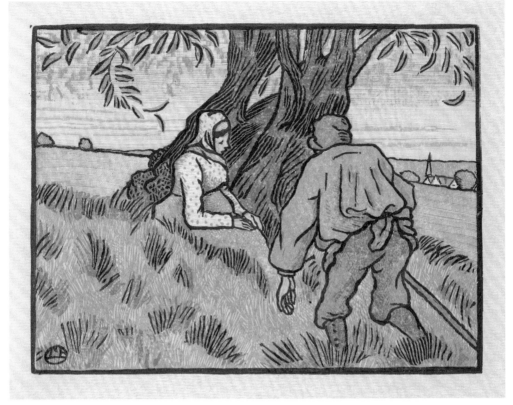

DITES, peut-on s'aimer ainsi,
~Branches tortes, branches mortes~
Peut-on s'aimer avec ces yeux
Avec ces pauvres yeux si vieux,
~Branches tortes, branches mortes~
Peut-on s'aimer, en raccourci,
Avec des corps si rabougris?
L'hiver est un grand bloc de froid
où sont sculptés clos et villages,
avec leurs chemins creux et leurs sillages,
l'horizon désert et des marais, là-bas.

c Branches

28 OF GARDENS. AN ESSAY, BY FRANCIS BACON. LONDON HACON & RICKETTS CRAVEN ST., STRAND, MCMII [1902]

Frontispiece designed and engraved on wood by Lucien Pissarro. Double border, one initial letter in red and seventy-six initial letters in black designed by Lucien Pissarro and engraved on wood by Esther Pissarro. Printed throughout in black, green and red in Vale type. Demy octavo. Colophon and press mark no. 3 in green. Twenty-eight leaves. 226 copies printed on Arnold's unbleached handmade paper with the Vale watermark of which 200 for sale at sixteen shillings. Quarter bound in pale grey paper, title stamped in gold upper left; paper covered boards, printed with roses in green and red on French grey.

Lucien had Bacon's essay on gardens in hand by February 1902. The theme would have appealed to the Pissarros, particularly to Esther who was a passionate gardener. The finished book appeared in April 1902, bound in boards covered with a pattern of roses first used on the Vale Press *De la typographie*. The frontispiece was designed and engraved by Lucien while the attractive double border on the first two pages of text and the initial letters were designed by Lucien and engraved by Esther.

[A] **Title page and frontispiece**

The frontispiece seems to have been originally intended for Villon's *Ballades*. The final large scale drawing and the reduced version in the Pissarro Archive are both inscribed 'Villon'. This must explain why Lucien dated the engraving in his catalogue of prints to 1899. Lucien designed an unused woodcut roundel of the girl on the right, dated 1901 in his catalogue of prints. This figure also relates to the woman gathering flowers in the frontispiece to Ronsard's *Choix de Sonnets* which appeared in September 1902.

Private collection

[B] **Pages 4 and 5**

Ashmolean Museum: Pissarro Archive: 77.3994

 OF GARDENS.

AN ESSAY, BY FRANCIS BACON.

LONDON
HACON & RICKETTS
CRAVEN ST., STRAND.

MCMII.

OF GARDENS.
AN ESSAY BY FRANCI
LORD BACON.

OD ALMIGHT
FIRST PLANTE
A GARDEN: AN
INDEED IT IS THE PUR
EST OF HUMAN PLEA
SURES. IT IS the GREAT
EST REFRESHMENT O
THE SPIRITS OF MAN
without WHICH, BUILI
INGS & PALACES AR
BUT GROSS HANDY
WORKS: AND A MA
SHALL EVER See, THA
WHEN AGES GROW T
CIVILITY & ELEGANC
MEN COME TO BUIL

TATELY, SOONER than
O GARDEN FINELY,
if GARDENING WERE
HE GREATER PERFEc-
ION. I DO HOLD IT, IN
HE ROYAL ORDERING
F GARDENS, THERE
UGHT to BE GARDENS
OR ALL THE MONTHS
N the YEAR: IN WHICH,
EVERALLY, THINGS of
EAUTY MAY BE THEN
N SEASON. FOR DEC-
MBER AND JANUARY,
& THE LATTER PART
f NOVEMBER, YOU must
AKE SUCH THINGS
S ARE GREEN all WIN-
ER; HOLLY, IVY, BAYS,
UNIPER, CYPRESS-trees,
EW, PINE-APPLE Trees,
IR TREES, ROSEMARY,

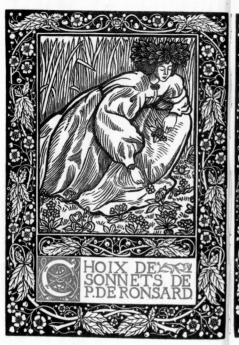
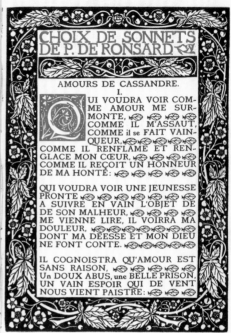

29 CHOIX DE SONNETS DE P. DE RONSARD [1902].

[Chosen Sonnets by Pierre de Ronsard]

Frontispiece designed and engraved on wood by Lucien Pissarro. Border and seventy-seven initial letters designed by Lucien Pissarro and engraved on wood by Esther Pissarro. Printed throughout in black and red. Vale type. Demy octavo. Colophon and press mark no. 3. Fifty leaves. 226 copies printed on Arches paper with the Eragny watermark of which 200 sold at thirty shillings. Quarter bound in pale grey paper, title stamped in gold upper left; paper covered boards, printed with hawthorn blossom, dark green and white on green.

Frontispiece and title page

The image of the girl picking flowers is one which Lucien used on a number of occasions. She appears in the frontispiece of Bacon's essay and in a variant frontispiece which was possibly designed for the same book. The image is printed in black and white but Lucien sent a coloured version to the *Gazette des Beaux-Arts* in 1910 using the same line block and adding four colour blocks.

Ashmolean Museum: Pissarro Archive: 77.3994

30 CHARLES PERRAULT. HISTOIRE DE PEAU D'ANE. (CONTE DE MA MÈRE LOYE) MCMII [1902]

[Charles Perrault: The Story of Donkey Skin]

Frontispiece designed and engraved by Lucien Pissarro. Borders and twenty initial letters designed by Lucien Pissarro and engraved on wood by Esther Pissarro. Three illustrations designed and engraved on wood by T. Sturge Moore. Printed throughout in black and red in Vale type. Small demy octavo. Colophon and press mark no. 3. Thirty-six leaves. 230 copies printed on Arches paper with the Eragny watermark of which 200 sold at twenty-one shillings. Quarter bound in grey-blue paper, title stamped in gold upper left; paper covered boards, printed with lotus flowers blue on white.

On 12 October 1901, Laurence Binyon sent Lucien details of an 1874 reprinting of Perrault's *Peau d'Ane*, presumably in response to a request from Lucien who was looking for a sequel to his first book of Perrault's tales. Lucien was also discussing illustrations for the new book with Binyon's friend, Thomas Sturge Moore, who was a close ally of Ricketts and Shannon at the Vale Press. Moore was trained as an artist and engraver although by 1902 he had begun devote more of his time to writing and hesitated to take up the offer. Eventually Moore designed and engraved three illustrations while the frontispiece and borders were reused from the first book of Perrault's tales. This was the first of four Eragny books which Lucien did not illustrate himself.

Title and first page

Moore's composition illustrates the episode in which the Infanta, dressed in the sun-coloured robe, covers her eyes in distress and leaves the company. The border, originally designed for the first volume of *Moralités légendaires* had previously been used for *The Baptism* in the first of the Perrault books. Moore's dense, overworked composition contrasts with the restraint which is a characteristic of all Lucien's book illustrations.

Ashmolean Museum: Pissarro Archive: 77.3996

ABREGÉ DE L'ART POETIQUE FRAN-
ÇOIS PAR PIERRE DE RONSARD.

A ALPHONSE DELBENE, ABBÉ DE
HAUTE-COMBE EN SAVOIE.

PISSARRO

E. ET. L. LONDON.

ERAGNY PRESS

MDCC CCIII.

LONDON
HACON & RICKETTS,
17 CRAVEN STREET, STRAND.

Scribendi rectè sapere est et principium et fons.

COMBIEN QUE l'ART DE POË-
SIE NE SE PUISSE PAR PRE-
CEPTES COMPRENDRE NY
ENSEIGNER POUR ESTRE
PLUS MENTAL QUE TRADI-
TIF, TOUTESFOIS D'AUTANT QUE
L'ARTIFICE HUMAIN, EXPERIENCE
& LABEUR LE PEUVENT PERMETTRE,
J'ay BIEN VOULU T'EN DONNER QUEL-
QUES REIGLES ICY, À FIN QU'UN JOUR
TU PUISSES ESTRE DES PREMIERS
EN LA COGNOISSANCE D'UN SI AG-
GREABLE MESTIER, À L'EXEMPLE DE
MOY QUI CONFESSE Y ESTRE ASSEZ
PASSABLEMENT VERSÉ. SUR TOU-
TES CHOSES TU AURAS LES MUSES
EN REVERENCE, VOIRE EN SINGULIE-
RE VENERATION, ET NE LES FERAS
JAMAIS SERVIR À CHOSES DES-HON-
NESTES À RISÉES, NY À LIBELLES
INJURIEUX; MAIS LES TIENDRAS
CHERES ET SACRÉES, COMME LES
FILLES DE JUPITER, C'EST À DIRE,

31 ABREGÉ DE L'ART POETIQUE FRANÇOIS PAR PIERRE DE RONSARD. A ALPHONSE DELBENE, ABBÉ DE HAUTE-COMBE EN SAVOIE. MDCCCCIII. LONDON HACON & RICKETTS, 17 CRAVEN STREET, STRAND [1902]

[Summary of the Art of Poetry by Pierre de Ronsard]

Title page with press mark designed and engraved on wood by Lucien Pissarro. Two borders, eleven headpieces, ten tailpieces and twelve initial letters designed by Lucien Pissarro and engraved on wood by Esther Pissarro. Vale type. Demy octavo. Colophon and press mark no. 3. Twenty-eight leaves. 226 copies printed on Arches paper with the Eragny watermark of which 200 sold at fifteen shillings. Quarter bound in pale grey paper, title stamped in gold upper left; paper covered boards, printed with hawthorn blossom, dark green and white on green. Two copies printed on old Ingres paper, one green, the other pink, not for sale.

Title and first page

The title-page includes the Pissarros' colophon within titles and ornamental borders. The use of the colophon would have saved the cost of a new block. The borders also incorporate ornaments reused in the head and tailpieces in the book. The text is more spaciously set out with ornamental letters, headpieces and tailpieces, designed by Lucien and engraved by Esther. This copy is inscribed to Lucien's father.

Ashmolean Museum: Pissarro Archive: 77.3997

32 C'EST D'AUCASSIN ET DE NICOLETE [1903]

[The Tale of Aucassin and Nicolete]

Frontispiece in five colours designed and engraved on wood by Lucien Pissarro. Initial letter in red and border designed by Lucien Pissarro and engraved on wood by Esther Pissarro. Vale and music type. Demy octavo. Colophon and press mark no. 3. Thirty-six leaves. 230 copies printed on Arches paper with the Eragny watermark of which 200 sold at thirty shillings. Quarter bound in pale grey paper, title stamped in gold upper left; paper covered boards, printed with verbena, green and blue on grey.

The thirteenth-century romance of Prince Aucassin and the humble Nicolete was often reprinted and translated in the nineteenth-century. F. W. Bourdillon published a translation of the single surviving manuscript into English in 1887 followed by a facsimile edition in 1896. Lucien's edition is based on an 1897 reprint of the facsimile with slight revisions. The text combines prose sections with songs and gave Lucien his first opportunity to include musical notation. Lucien liked short fairy tales and romances, partly because they were short but also because he was attracted by stories of fantasy, particularly when they had a rustic setting. The frontispiece shows Nicolete sitting under her shelter on the edge of a wood waiting for Aucassin from whom she had been separated by his cruel father. This was the last Eragny book to be printed with the Vale type.

[A] **Lucien Pissarro:** *Study for Nicolete*
Black and white chalks on brown paper
301 × 240 mm

One of several studies of the seated Nicolete

Ashmolean Museum: Pissarro Archive: 77.1872

[B] **Lucien Pissarro:** *Study for Nicolete*
Black and white chalks on brown paper
295 × 237 mm

Ashmolean Museum: Pissarro Archive: 77.1871

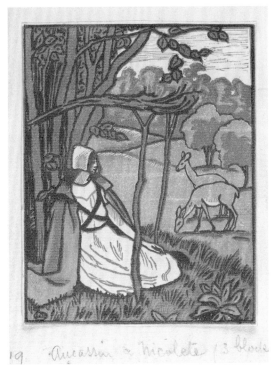

[c] **Woodblock** *not illustrated*

Stamped on the verso: *T. Lawrence*

A variant of the frontispiece, perhaps cut before the others and rejected at an early stage. The block has traces of red ink and must have been used for printing but no prints are known.

Ashmolean Museum: Pissarro Archive: 77.4228

[d] **Frontispiece: first version**

Printed in three shades of brown: 122 × 98 mm

A rare impression of the first print pasted into Lucien's own catalogue of his wood-engravings.

Ashmolean Museum: Pissarro Archive: WA1973.156

[E] Camille Pissarro: *Nicolete*

Pen and Indian ink over pencil with brown wash,
touched with white gouache
125 × 100 mm

On 2 December 1902, Lucien sent his father
a proof of the frontispiece. He was unhappy
with the effect of the half tone which tended
to swamp the image. On 23 December
he sent Camille separate prints from the
line block and from the half-tone block
to enable his father to assess the problem.
Camille replied to both letters with a list
of criticisms: the foreground trees were
confused and too detailed: the background
trees needed firmer outlines: the whiteness
of the figure was disturbing. He included
this sketch in his letter with instructions on
how to improve the balance of tones. Lucien
agreed with the suggestions. In order to
lessen the effect of white in the sky (which
competed with the white on the figure) and
to deal with the offending trees, he engraved
a new block with the top section removed
and printed it in softer tones. Camille was
not convinced. The seated figure was still too
white and the foreground trees were badly
drawn. He suggested placing the foreground

and the figure in greater shadow and leaving
the background in the light. Lucien had
doubts if he could alter the tonality and
he did not feel able to improve the trees
before spring when he could study trees in
leaf. Instead, he reprinted the frontispiece,
using the line block and added three colour
blocks, pale brown, yellow and pink. Camille
found this better but still hard and cold and
accused his son of having deviated from
the true road of nature to follow the 'Anglo-
Italian' manner.

Ashmolean Museum: Pissarro Archive: OA.1673

[G] Frontispiece, as published

Printed from five blocks. This copy is
inscribed from Esther and Lucien to
Esther's sister, Ruth.

Ashmolean Museum: Pissarro Archive: 77.4000

[H] Binding

Private collection

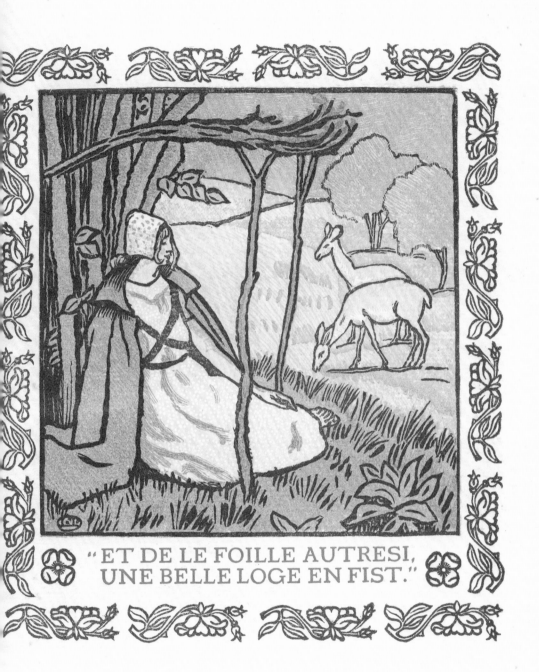

"ET DE LE FOILLE AUTRESI,
UNE BELLE LOGE EN FIST."

33 A BRIEF ACCOUNT OF THE
ORIGIN OF THE ERAGNY PRESS &
A NOTE ON THE RELATION OF THE
PRINTED BOOK AS A WORK OF ART
TO LIFE BY T. STURGE MOORE. A
BIBLIOGRAPHICAL LIST OF THE
ERAGNY BOOKS PRINTED IN THE
VALE TYPE BY ESTHER & LUCIEN
PISSARRO ON THEIR PRESS AT
EPPING, BEDFORD PARK, AND THE
BROOK, CHISWICK, IN THE ORDER
IN WHICH THEY WERE ISSUED
[1903]

Fourteen illustrations printed from previous
Eragny books designed by Lucien Pissarro and
engraved on wood by Lucien and Esther Pissarro.
Brook type. Small demy octavo. Colophon
and press mark no. 3. Thirty-three leaves. 235
copies printed on Arches paper with the Eragny
watermark of which 200 for sale at twenty-five
shillings. Quarter bound in pale grey paper, title
stamped in gold upper left; paper covered boards,
printed with daisies, green and red on white.
Six vellum copies of which three were for sale at
five guineas.

The closing of the Vale Press in 1903 brought
an end to the agreement with Ricketts to
publish the Eragny books. This also ended
the agreement to use the Vale type. In 1901,
Lucien had already begun to design his own
type, named the Brook after the house in
Hammersmith. With financial help from
his father, he commissioned Edward Prince
to engrave the punches and reached an
agreement with Shanks and Sons to cast the
type. Although the Brook type was based
on a fifteenth-century Italian text, it is (as
Camille noted) very similar to the Vale type.
The change was marked by the publication
of a history of the Eragny Press, written by
Sturge Moore, with a catalogue of previous
publications and fourteen woodcuts from
earlier books. This was the first Eragny book
printed with the Brook type.

[A] **Prospectus**

The prospectus incorporates the third
Eragny press mark, engraved to replace

the second mark which was withdrawn
following the complaint by Elkin Mathews.
The third press mark appeared for the first
time in the edition of Villon's *Ballades*,
published in 1900 and was used in all Eragny
books thereafter. The ribbon is inscribed
with the names of Esther and Lucien in
place of the offending motto.

Ashmolean Museum: Pissarro Archive: OA.1684

[B] **Pages 3 and 4**

This copy was given to Esther's father,
J. S. L. Bensusan, by Esther and Lucien.

Ashmolean Museum: Pissarro Archive: 77.3998

(No. I.) ❧ NOW READY:
A BRIEF ACCOUNT
OF THE ORIGIN OF
the ERAGNY PRESS
& A NOTE OF THE
RELATION OF THE
PRINTED BOOK TO
LIFE. By T. STURGE
MOORE. A BIBLIO,
GRAPHICAL LIST of
the ERAGNY PRESS
BOOKS PRINTED IN
THE VALE TYPE
BY ESTHER & LU,
CIEN PISSARRO ON
THEIR PRESS AT
EPPING, BEDFORD
PARK & CHISWICK.

MR. PISSARRO first learned to draw from his father, in the fields far from any art school. One day M. Lepère, the well-known engraver, showed him how his tools were held, & finding him interested, gave him two gravers and a scorper. Thus furnished with the means he made a start and taught himself; with the result that in 1886 F. G. Dumas, editor of the «Revue Illustrée», commissioned him to illustrate a story, «Maît' Liziard», by Octave Mirbeau. Four woodcuts appeared, but the subscribers to the Review expressed so much disapproval of these illustrations, conceived and executed in the uncompromising spirit of Charles Keene's work, which Mr. Pissarro greatly admired, that his collaboration was cut short there and then. He learnt later that this epistolary demonstration against his work, which inundated Mr. Dumas' office, was the work of some students in the atelier of a well-known painter. Disappointed, and having heard that in England there was a group of young artists who were ardently engaged in the revival of wood-engraving, he crossed the Channel with the intention of joining them, having in his pocket an introduction from Félix Fénéon to John

4 Gray

34 AREOPAGITICA. A SPEECH
OF MR. JOHN MILTON FOR THE
LIBERTY OF UNLICENC'D PRINTING,
TO THE PARLAMENT OF ENGLAND
[1903]

Border, large initial letter in red and twenty-seven initial letters in black designed by Lucien Pissarro and engraved in wood by Esther Pissarro. Small demy quarto. Colophon and press mark no. 3. Twenty-six leaves. Brook and Greek types in black and red. 226 copies printed on Arches paper with the Eragny watermark of which 200 for sale at thirty-one shillings and sixpence. Quarter bound in cream paper with blue paper boards, the title printed in dark green upper left, with a carnation on a ground of flames in green, red, yellow and blue on a label upper right. Ten vellum copies of which eight for sale at seven guineas.

The first printing of *Areopagitica* carries a completion date of October 1903 but it was not published until five months later. On the night of 23 November 1903, a fire at the bindery of Leighton, Son and Hodge destroyed all but forty of the 226 paper copies. Lucien was in Paris at the time, dealing with his father's estate. Esther remained in London, staying with neighbours while The Brook was rented and managing the affairs of the press. Lucien advised Esther against a reprint as sales were doubtful and their financial position was not secure. Esther, however, proceeded to reprint. The second edition was ready for distribution in April 1904. Both editions were produced in a larger format than any other book from the Eragny Press.

[A] **First page**

This was the second book to be printed with the Brook type. The Greek text on the title page was printed using type designed by Selwyn Image and borrowed from Macmillan.

Ashmolean Museum: Pissarro Archive: 77.400

[B] **Notice to subscribers**

As the text makes clear, Esther at first believed that the entire paper edition had been destroyed in the fire at the bindery. A second notice sent to subscribers advised them that collated sheets of forty copies had, in fact, been rescued and would be made available in a special binding.

> ERAGNY PRESS.
> Lucien and Esther Pissarro regret to announce that their entire issue of MILTON'S AREOPAGITICA, with the exception of the ten vellum copies, was destroyed on the night of Monday, 23rd November, by the fire at the Binders (Messrs. Leighton, Son, and Hodge).
> The book will be done again as rapidly as is consistent with the care and attention demanded, and it will be published in March, 1904. Since the border block seems not to be sufficiently strong to print the whole of the edition it will have to be limited to about 150 copies including the American edition, and as this is nearly subscribed orders should be sent in at once.
> Subscribers to the «Areopagitica» can have their money returned on application, or it can remain at their credit, in which case they will receive the book as soon as it is ready.
> The next publication of the Eragny Press will be «The Descent of Ishtar,» by Diana White, which will be issued at the end of December. A prospectus of this will be sent out in due course.

FOR THE LIBERTY OF UNLICENC'D PRINTING.

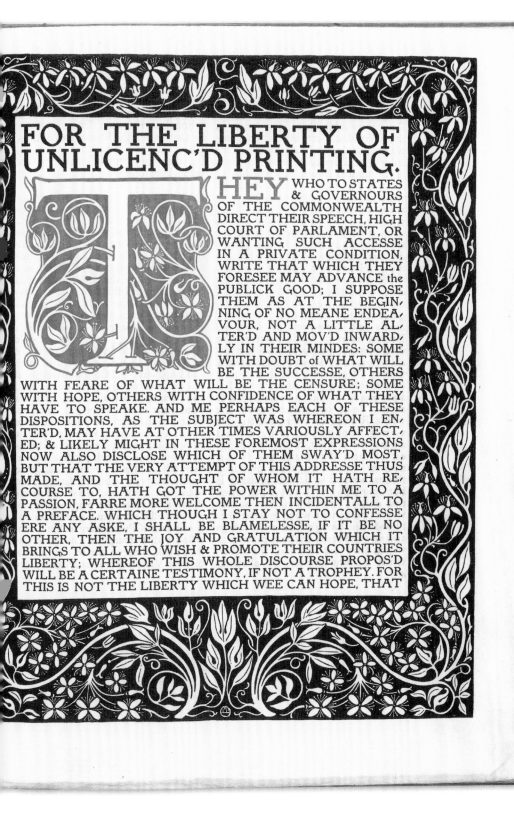

THEY WHO TO STATES & GOVERNOURS OF THE COMMONWEALTH DIRECT THEIR SPEECH, HIGH COURT OF PARLAMENT, OR WANTING SUCH ACCESSE IN A PRIVATE CONDITION, WRITE THAT WHICH THEY FORESEE MAY ADVANCE the PUBLICK GOOD; I SUPPOSE THEM AS AT THE BEGINNING OF NO MEANE ENDEAVOUR, NOT A LITTLE ALTER'D AND MOV'D INWARDLY IN THEIR MINDES: SOME WITH DOUBT of WHAT WILL BE THE SUCCESSE, OTHERS WITH FEARE OF WHAT WILL BE THE CENSURE; SOME WITH HOPE, OTHERS WITH CONFIDENCE OF WHAT THEY HAVE TO SPEAKE. AND ME PERHAPS EACH OF THESE DISPOSITIONS, AS THE SUBJECT WAS WHEREON I ENTER'D, MAY HAVE AT OTHER TIMES VARIOUSLY AFFECTED; & LIKELY MIGHT IN THESE FOREMOST EXPRESSIONS NOW ALSO DISCLOSE WHICH OF THEM SWAY'D MOST, BUT THAT THE VERY ATTEMPT OF THIS ADDRESSE THUS MADE, AND THE THOUGHT OF WHOM IT HATH RECOURSE TO, HATH GOT THE POWER WITHIN ME TO A PASSION, FARRE MORE WELCOME THEN INCIDENTALL TO A PREFACE. WHICH THOUGH I STAY NOT TO CONFESSE ERE ANY ASKE, I SHALL BE BLAMELESSE, IF IT BE NO OTHER, THEN THE JOY AND GRATULATION WHICH IT BRINGS TO ALL WHO WISH & PROMOTE THEIR COUNTRIES LIBERTY; WHEREOF THIS WHOLE DISCOURSE PROPOS'D WILL BE A CERTAINE TESTIMONY, IF NOT A TROPHEY. FOR THIS IS NOT THE LIBERTY WHICH WEE CAN HOPE, THAT

[c] Binding

The pages saved from the fire were bound in boards faced with blue Michallet paper. The flames in the label refer to the fire at the bindery. Apart from the binding and the text of the colophon, the two editions are identical.

Private collection

[D] Binding: quarter bound in blue paper, stamped with the title in gold in upper left with paper boards printed with a pattern of carnations in pink and green.

This is the binding of the second edition which repeats the single motif of the carnation intended for the first edition. According to the notice sent to subscribers, the block used for the border page was not strong enough to print more than 160 copies. Of these, 134 were for sale at thirty-one shillings and sixpence.

Ashmolean Museum: Pissarro Archive: 77.4001

35 THE DESCENT OF ISHTAR. BY DIANA WHITE [1903]

Frontispiece, designed by Diana White and engraved on wood by Esther Pissaro; two borders in green and five initials in red designed by Lucien Pissarro and engraved by Esther Pissarro. Small demy 12o. Colophon and press mark no. 3. Sixteen leaves. Brook type in red, black and green. 226 copies printed on Arches paper with the Eragny watermark of which 200 for sale at twelve shillings and sixpence. Quarter bound in grey/green paper, title printed in red on label upper left; paper boards with daisies in dark green on pale green. Ten vellum copies of which eight for sale at three guineas.

Esther had been a friend of Diana White since they had met as students at the Crystal Palace School of Art. Diana had a brief career as a translator in the 1890s and a longer one as a painter. The text of *The Descent of Ishtar* had appeared first in *The New Review* in 1897. This is closely based on a translation of an ancient Assyrian tale with additions to fill in missing parts. Three translations from recently discovered cuneiform tablets had been published in the 1870s at a time of great popular interest in the Assyrians and their literature. The exotic and allegorical character of the tale was also perfectly in keeping with the tastes of Ricketts and his friends at the Vale Press, including Lucien, whose books included several short mythic stories of this kind. Almost as soon as the project was agreed, Lucien had to leave for France following the death of his father, leaving the book entirely in Esther's hands. Lucien sent his advice from Paris which Esther seems, on the whole, to have ignored. Lucien told her not to print more than 150 copies but 226 were printed. Lucien did not care for the leaf motif in the margin and was unhappy with the size of the initial letters.

[A] Frontispiece and first page

The border round the frontispiece was originally made for Bacon's *Of Gardens* but the frontispiece itself was drawn by Diana White for the book and engraved by Esther. It shows Ishtar's lover, Tammuz, languishing in the Underworld. There is a dissonance in style between the image and the border. Lucien, echoing his father's criticism of his own work, told Esther that Diana White's work was too Neo-Pre-Raphaelite and not naturalistic enough for his taste. Esther's reply does not survive but from Lucien's subsequent letter, it is clear she was annoyed with his remarks.

Ashmolean Museum: Pissarro Archive: 77.3999

[B] Binding

The paper cover was designed by Diana White. Esther hoped that the completed book would be delivered on 24 December but difficulties with the binders over the facing paper and the label delayed deliveries until February.

Private collection

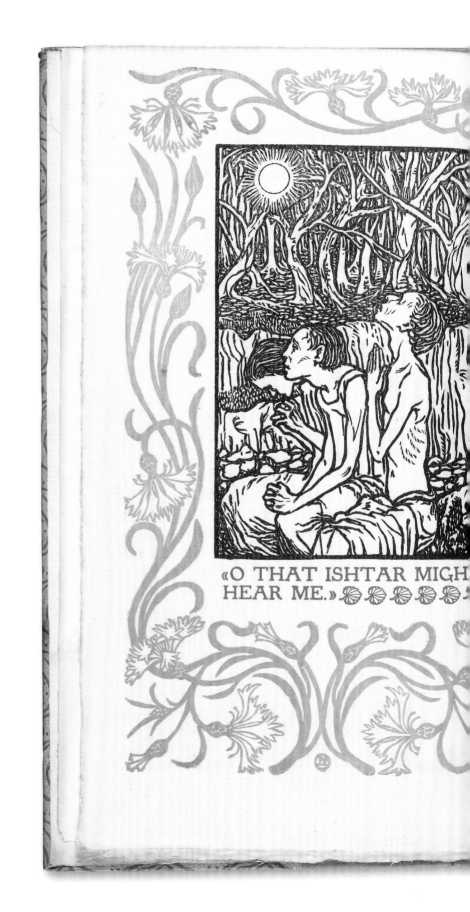

«O THAT ISHTAR MIGH[T]
HEAR ME.» 🌼🌼🌼🌼🌼

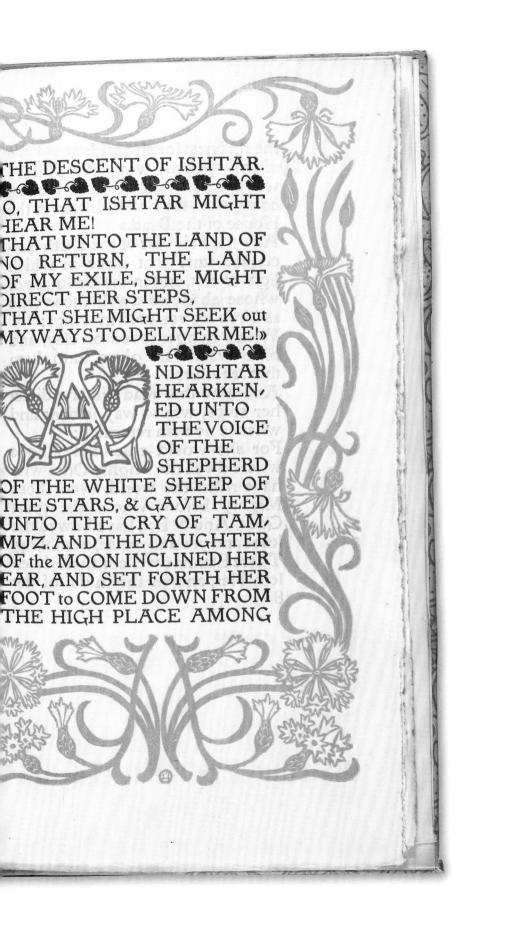

THE DESCENT OF ISHTAR.

O, THAT ISHTAR MIGHT HEAR ME! THAT UNTO THE LAND OF NO RETURN, THE LAND OF MY EXILE, SHE MIGHT DIRECT HER STEPS, THAT SHE MIGHT SEEK out MY WAYS TO DELIVER ME!»

AND ISHTAR HEARKENED UNTO THE VOICE OF THE SHEPHERD OF THE WHITE SHEEP OF THE STARS, & GAVE HEED UNTO THE CRY OF TAM, MUZ. AND THE DAUGHTER OF the MOON INCLINED HER EAR, AND SET FORTH HER FOOT to COME DOWN FROM THE HIGH PLACE AMONG

36 SOME POEMS BY ROBERT BROWNING [1904]

Frontispiece designed and engraved on wood by Lucien Pissarro and printed in five colours; ten initials in red designed by Lucien Pissarro and engraved by Esther Pissarro. Small demy octavo. Colophon and press mark no. 3. Forty leaves. Brook type. 215 copies printed on Arches paper with the Eragny watermark of which 200 were for sale at thirty shillings. Quarter bound in grey/green paper, title stamped in gold upper left; paper boards with wild roses in pale green and pink on cream. Eleven vellum copies of which nine were for sale at seven pounds.

In February 1904, Lucien wrote to Esther from France to let her know that he was waiting for his friend, Robert Steele, to select a number of poems by Browning for publication by the Press. By May, work on the book was in hand. It was published in June with eleven poems, a coloured frontispiece and red initials.

[A] Prospectus

Ashmolean Museum: Pissarro Archive: OA.1685

[B] Frontispiece

The frontispiece illustrates the fifth poem, the poet's dream of a rose tree encircled by women from the past, present and future.

Private collection

[C] Binding

The theme of roses, included in the frontispiece, is taken up in the pattern on the cover.

Ashmolean Museum: Pissarro Archive: 77.4003

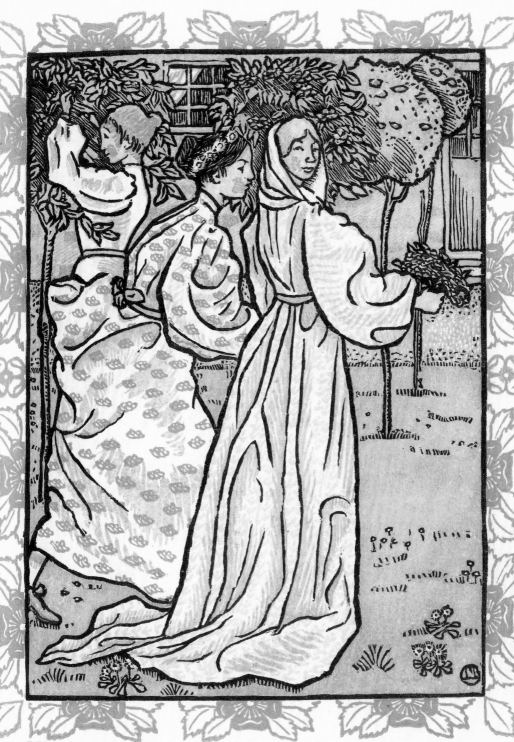

Women and Roses.

37 CHRISTABEL, KUBLA KHAN, FANCY IN NUBIBUS, AND SONG FROM ZAPOLYA. BY SAMUEL TAYLOR COLERIDGE. [1904]

Frontispiece designed and engraved on wood by Lucien Pissarro, printed in two shades of green. Border on first page and initial letter designed by Lucien Pissarro and engraved by Esther Pissarro, printed in red and green. Three initials designed by Lucien Pissarro and engraved by Esther Pissarro. Small demy octavo. Colophon and press mark no. 3. Twenty-nine leaves. Brook type. 226 copies printed on Arches paper with the Eragny watermark of which 200 were for sale at one guinea. Quarter bound in dark grey/green paper, title stamped in gold upper left; paper boards with violets in dark green and lilac on pale green. Ten vellum copies of which eight were for sale at five guineas.

Lucien initially asked Diana White to make a selection of poems by Coleridge for a new book but as she did not have time he turned to T. S. Moore. On 14 June 1904, Moore wrote to Lucien, recommending *Christabel* because it was Coleridge's best-known poem after *The Ancient Mariner*. The latter, in any case, had already been reprinted by Ricketts. Moore suggested adding *Kubla Khan* as the second poem in the book and on 2 July he wrote again to recommend the 1828 edition of Coleridge's poems as the best source and suggested adding *Fancy in Nubibus* if a third poem was needed. The book was published in October 1904 with the three poems which Moore had recommended and the short *Song from Zapolya* added as a space filler. Coleridge's preface to *Christabel* was also inserted at Moore's suggestion.

[A] Frontispiece and title

Lucien began to cut the half tone block for the frontispiece in July 1904. Esther must have warned him about the difficulty in getting orders as he wrote to her suggesting that they might omit the frontispiece to cut costs but asking her to arrange the sheets when printing to enable them to include the frontispiece if wanted. The frontispiece, representing Christabel in the 'midnight wood' was included as intended, printed in two tones of green in the manner of the Italian chiaroscuro prints which Lucien admired. This is one of ten vellum copies of which eight were made for sale. The smooth vellum gave a particular lustre to the printing and vellum copies were prized by collectors.

Private collection

[B] First page

The border was cut for a discarded frontispiece, possibly designed for Bacon's *Of Gardens*.

Ashmolean Museum: Pissarro Archive: 77.4005

[C] Kieffer binding

On 12 October 1913, the Paris binder, René Kieffer, wrote to Lucien to ask if he might acquire a number of the Eragny books for a client. Lucien sent the books requested and asked Kieffer to bind this vellum copy of *Christabel* for himself.

Ashmolean Museum: Pissarro Archive: 77.4004

CHRISTABEL, ❧ KUBLA KHAN,
❧ FANCY IN NUBIBUS, AND ❧ SONG
FROM ZAPOLYA.
BY SAMUEL TAYLOR COLERIDGE.

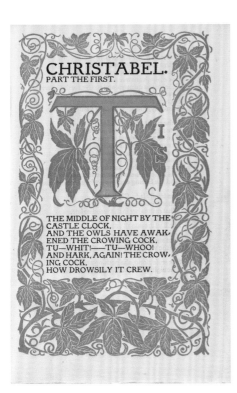

CHRISTABEL.
PART THE FIRST.

TI

THE MIDDLE OF NIGHT BY THE
CASTLE CLOCK,
AND THE OWLS HAVE AWAK-
ENED THE CROWING COCK,
TU—WHIT!——TU—WHOO!
AND HARK, AGAIN! THE CROW-
ING COCK,
HOW DROWSILY IT CREW.

❧ I. LES PRINCESSES AU POMMIER DOUX.

ER-RIER' chez mon pé-re,

6

Vole, mon cœur, vole! Derrier' chez mon

pére, Ya un pom-mier dous,

Ya un pommier dous, Tout dous! Et

you! Ya un pommier dous.

Derrier' chez mon pére,
Vole, mon cœur, vole!
Derrier' chez mon pére,
Ya un pommier dous,
Ya un pommier dous,
Tout dous!
Et you!
Ya un pommier dous.

Trois jeunes princesses
Vole, mon cœur, vole!
Trois jeunes princesses
Sont couché's dessous

c

7

❧ IV. SAINT NICOLAS ET LES EN-
FANTS AU SALOIR.

L é-toit trois pe-tits enfans,
Ils sont tant al - lés et venus

Qui s'en alloient glaner aux chams.
Que le soleil on n'a plus vu.

S'en sont al-lés chez un bou-cher:

❧ «Boucher, vou-drois-tu nous lo-ger?»

❧ «Al-lez, al-lez, mes beaus en-fans,

«Nous a-vons trop d'em-pê-che-ment.»

14

Il é-toit trois pe-tits en-fans.

Il étoit trois petits enfans,
Qui s'en alloient glaner aux chams.
Ils sont tant allés et venus
Que le soleil on n'a plus vu.

S'en sont allés chez un boucher:
❧ «Boucher, voudrois-tu nous loger?»
❧ «Allez, allez, mes beaus enfans,
Nous avons trop d'empêchement.»
Il étoit trois petits enfans.

Sa femme qu'étoit derrier' lui,
Bien vitement le conseillit:
❧ «Ils ont,» dit-elle, «de l'argent,
«Nous en serons riches marchans.»
Il étoit trois petits enfans.

«Entrez, entrez, mes beaus enfans!
«Ya de la place assurément.
«Nous vous ferons fort bien souper,
«Aussi bien blanchement coucher.»
Il étoit trois petits enfans.

Ils n'étoient pas sitôt entrés,
Que le boucher les a tués,

e

15

38 SOME OLD FRENCH AND ENGLISH BALLADS EDITED BY ROBERT STEELE [1905]

Frontispiece designed and engraved on wood by Lucien Pissarro, printed in five colours. Nineteen initial letters in red. Small demy octavo. Colophon and press mark no. 3. Thirty-seven leaves. Brook and music types in red and black. 200 copies printed on Arches paper with the Eragny watermark of which 175 for sale at thirty-five shillings. Quarter bound in dark grey/green paper, title stamped in gold upper left; paper boards with winter jasmine in green and yellow on pale grey/green. Ten vellum copies of which eight for sale at seven guineas.

Lucien commissioned this edition of ballads from his friend Robert Steele for a fee of five guineas. Steele, like Lucien, was a disciple of Morris and took a particular interest in manuscripts, the history of printing and early printed music. Lucien began work on the colour blocks before he left France at the end of March 1904. The music type was based on sixteenth-century notation and cast by P. M. Shanks and Son. The quality of the casting proved a great disappointment. Registration was difficult. In most cases the Pissarros cut off the the tails of the minims and used the diamond heads. This involved much troublesome retouching of the notes. By 25 January 1905, Steele had not yet submitted the music for *Colle to me the ryshes grene*, the text of the prospectus, nor the preface. It was hoped to publish before Christmas but with longer delays than they had ever experienced before in producing a book, it was not ready until March. The price of the paper copies meanwhile went up from thirty shillings to thirty-five.

[A] Opening pages

The roundel, printed in five colours, illustrates the three princesses under an apple tree, mentioned in the first song.

Private collection

[B] Pages 14 and 15

The extensive use of red added to the cost of production.

Ashmolean Museum: Pissarro Archive: 77.4008

39 DREAM-COME-TRUE. POEMS BY LAURENCE BINYON [1905]

Frontispiece designed and engraved on wood by Laurence Binyon, printed in green. Double border, printed in green, and fourteen initial letters, one in red, designed by Lucien Pissarro and engraved on wood by Esther Pissarro. Small demy 12o. Colophon and press mark no. 3. Twenty-six leaves. Brook type. 175 copies printed on Arches paper with the Eragny watermark of which 150 were for sale at twelve shillings and sixpence. Quarter bound in blue paper, title on printed label upper left; paper boards with daisies, green and pink on white. Ten vellum copies of which eight were for sale at three guineas.

On 15 September 1904, Binyon wrote to Lucien to ask if he would consider printing about twelve of his recent short love poems. These were then unpublished but he requested the right to publish them some day in a larger book. On 30 January, he sent Lucien the completed manuscript. Lucien gave him an estimate of £45 which included a 20 fee to cover Lucien's input. Binyon hesitated to design the frontispiece himself, pleading a lack of skill and time, but by 15 March, he had sketched out an idea and sent it to Selwyn Image to improve. By 31 March, Image had returned the sketch. Binyon took it with him on holiday to Broadstairs, cut the block while he was there and sent it to Lucien on 6 April. On 18 April, the pages were sent to the bindery and Binyon received his copy at the beginning of May.

Opening pages

Binyon's woodcut is enclosed in a border originally designed for *Of Gardens* and used again in Diana White's *Ishtar*.

Ashmolean Museum: Pissarro Archive: 77.4006

❧ DREAM·COME·TRUE·

❧ I.

WITHIN THE EYE
OF DREAM·COME
TRUE
SHINE THE OLD DREAM
OF MY YOUTH.
ERE THEY FADED, ERE
THEY GREW

DISTANT, THEY WERE
BORN ANEW
IN HER TRUTH.

WITHIN THE HEART OF
DREAM, COME, TRUE
LIES MY LIFE, A FOLDED
BUD:
ALL THAT IS TO HOPE AND
DO,
JOY AND TRIUMPH, TOIL &
RUE,
SKIES OF THUNDER, SKIES
OF BLUE
PULSE IN PULSES OF HER
BLOOD.
O MAY THE FOUNTAIN
LEAP IN FLOOD
THE YOUNG SHOOT
BRANCH IN LEAFY WOOD,
BLEST IN PROMISE
THROUGH AND THROUGH
BY THE DEAR THOUGHTS
OF DREAM, COME, TRUE!

40 THE LITTLE SCHOOL, A POSY OF RHYMES, BY T. STURGE MOORE. [1905]

Frontispiece, tailpiece and two headpieces designed and engraved on wood by Thomas Sturge Moore. Twenty-five initial letters designed by Lucien Pissarro and engraved on wood by Esther Pissarro. Small demy 12o. Colophon and press mark no. 3. Thirty-three leaves. Brook type. 175 copies printed on Arches paper with the Eragny watermark of which 150 for sale at eighteen shillings. Quarter bound in grey/green paper, title stamped in gold upper left; paper boards with daffodils, green on pale green. Ten vellum copies of which eight were for sale at four guineas.

Binyon's book was the first in a projected series of modern authors. This was the second title in the series. Diana White's *Descent of Ishtar* is a book of the same type but Lucien thought it would be wrong to

❧ THANKS ARE DUE TO THE EDITORS OF THE «DIAL» AND THE «ACADEMY» FOR PERMISSION TO REPRINT SOME FEW OF THE POEMS IN THIS, THE FIRST EDITION OF «THE LITTLE SCHOOL» WHICH will REMAIN UNIQUE in THE NUMBER AND ARRANGEMENT OF ITS CONTENTS, ITS FOUR WOODCUTS by THE AUTHOR & ALL FEATURES COMMON TO «ERAGNY PRESS» BOOKS. ♣ PRINTED BY LUCIEN & ESTHER PISSARRO AT THE BROOK, HAMMERSMITH, & FINISHED IN JULY, 1905.

SOLD BY THE ERAGNY PRESS, LONDON, AND JOHN LANE, NEW YORK.

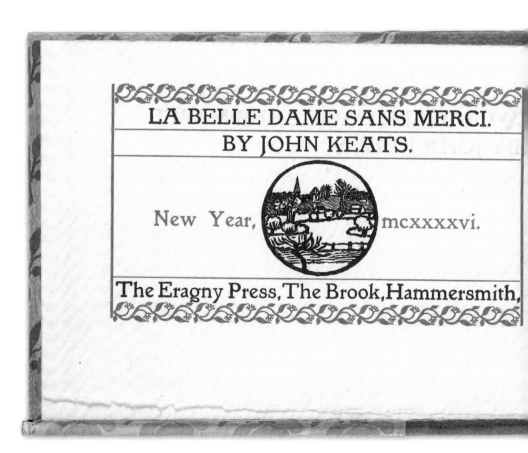

LA BELLE DAME SANS MERCI.
BY JOHN KEATS.

New Year, mcxxxxvi.

The Eragny Press, The Brook, Hammersmith,

include it in the modern series as they had not intended making a series at the time it was published. All three are illustrated by their authors and are similar in format. Moore designed and cut three headpieces and the title page for his book of poems. It was published in July 1905 after a particularly bitter complaint from Esther to the binders about the quality of the work. The arrangement between Moore and the Pissarros must have been fairly informal. Moore was clearly expecting some kind of return for his efforts but responded with typical generosity when Esther told him at the end of the month that he could expect no money from the sales. The book had cost £172 and had brought in about £87 to date.

Colophon

Ashmolean Museum: Pissarro Archive: 77.4007

41 LA BELLE DAME SANS MERCI. BY JOHN KEATS. New Year 'Vue d'Eragny' mcxxxxvi The Eragny Press, The Brook, Hammersmith [1905]

Frontispiece designed and engraved on wood by Lucien Pissarro. Two initial letters in red designed by Lucien Pissarro and engraved on wood by Esther Pissarro. Oblong demy 32mo. Colophon but no press mark. Twenty-one leaves. Brook type. 200 copies printed on Arches paper for sale at five shillings. Quarter bound in grey/blue paper, title on a printed label upper left; paper boards with roses, green and yellow on cream. Ten copies on Roman vellum for sale at one guinea.

A book of Ben Jonson's songs, begun in June 1905 in the hope of completing it within the year, was not ready until the following April. On 3 December, Lucien told Maggs the bookseller that he had produced a booklet with two versions of Keats's *La*

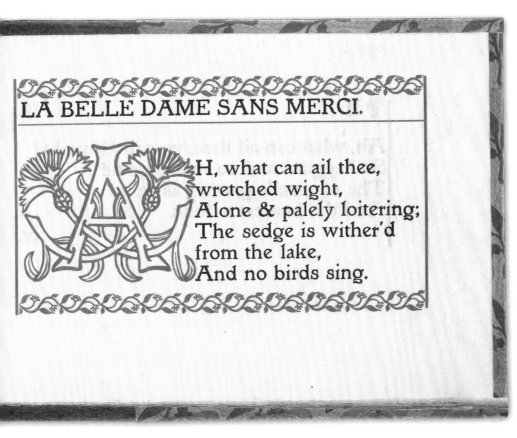

Belle dame sans merci to fill the gap in the market at Christmas and New Year. The book was hurried into production. The little view of Eragny in the roundel had originally been made for a catalogue of a Camille Pissarro exhibition in 1893 and was conveniently and inexpensively to hand. The paper cover, also, made use of an existing design, made originally for *Of Gardens*, but with the flowers printed in yellow. While companion books printed in Vale type – the two Perraults, Ronsards, Flauberts and Villons – were covered in matching papers, this was the only book printed in Brook type covered with a paper of an existing pattern. As always, the book ran into trouble at the binders. On 7 December, Esther complained to Leighton that nearly every page in the edition had off-set during binding. The problem was probably a result of the haste with which the book had been produced. The poem was sent out to subscribers in the second week of December. Campbell Dodgson, Binyon's colleague at the British Museum, immediately pointed out that the date of publication on the title page was written: mcxxxxvi (ie, 1146) instead of mdccccvi (1906). On 13 December, in some dismay, the Pissarros began a reprint and contacted the subscribers. The latter must have replied with remarkable speed as Esther cancelled the order for rebinding on 15 December on the grounds that 'many people wish to keep the books as they are'. An erratum slip was inserted and the error was left unaltered.

Frontispiece and title page

Ashmolean Museum: Pissarro Archive: 77.4009

42 SONGS BY BEN JONSON. A SELECTION FROM THE PLAYS, MASQUES, AND POEMS, WITH THE EARLIEST KNOWN SETTINGS OF CERTAIN NUMBERS. THE ERAGNY PRESS, THE BROOK, HAMMERSMITH, LONDON, W. [1906]

Frontispiece in four colours designed and engraved on wood by Lucien Pissarro. Border, one large initial letter in red and forty-five smaller initial letters in red designed by Lucien Pissarro and engraved on wood by Esther Pissarro. Small demy octavo. Colophon and press mark no. 3. Thirty-eight leaves. Brook type. 175 copies printed on Arches paper with the Eragny Press watermark of which 150 for sale at forty shillings. Quarter bound in blue/grey paper, title stamped in gold upper left; paper boards with speedwells, green and blue on white. Ten copies on Roman vellum of which eight for sale at seven guineas.

On 13 June 1905, Lucien wrote to Esther from Finchingfields to say that Moore had sent him a collection of poems by Ben Jonson which might make a book. He wondered if Binyon could find someone to help with the music but worried that he might offend Robert Steele whom he had already consulted about this. On 20 June, he told Esther that he could already see in his mind's eye a little book, printed in black and red, which would justify a price of one pound, despite the small size. At Binyon's suggestion he approached the musicologist William Barclay Squire for advice about the music. Printing with the music type took longer than anticipated and there were, again, problems with the binding. Delivery, already delayed, was promised on 23 April 1906 but the books did not appear until 25 April when the Pissarros began distribution. This pretty, elegantly printed book was well received by subscribers but sold badly. The sales were catastrophic for the Pissarros who were left in debt. Lucien had to lay off their loyal printer, Thomas Taylor, in May and borrowed 3,500 francs from Monet in October.

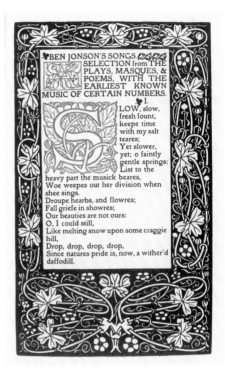

[A] **Binding**

Private collection

[B] **First page**

Private collection

[C] **Advertisement for an edition of Herrick's songs**

Lucien had hoped to follow Jonson's songs with a similar book of songs by Herrick with printed music but the difficulties with Jonson persuaded him to attempt to sell the new book through advance subscriptions. As there was insufficient interest, the book was abandoned.

Ashmolean Museum: Pissarro Archive: OA.1686

43 VERSES BY CHRISTINA
G. ROSSETTI. REPRINTED FROM
G. POLIDORI'S EDITION OF
1847. EDITED BY J. D. SYMON.
THIS REPRINT IS MADE BY
ARRANGEMENT WITH MESSRS.
MACMILLAN & CO., LTD., AND SOLD
AT THE ERAGNY PRESS, THE BROOK,
HAMMERSMITH, LONDON, W. [1906]

Two borders in red, one large initial letter and
forty small initial letters designed by Lucien
Pissarro and engraved on wood by Esther
Pissarro. Small demy octavo. Colophon and press
mark no. 3. Forty-seven leaves. Brook type. 175
copies printed on Arches paper with the Eragny
Press watermark of which 150 for sale at one
guinea. Quarter bound in blue/grey paper, title
stamped in gold upper left; paper boards printed
with saxifrage in green and yellow on cream. Ten
copies on Roman vellum of which eight for sale at
five guineas.

After the problems with Ben Jonson,
Lucien and Esther began work on a more
modest work, reprinting an 1847 edition of
the poems of Christina Rossetti, with no
colour apart from some red on one orna-
ment. On 30 July, when the book had been
set up and all but three of the forms had
been printed, Macmillan and Co. informed
Lucien that as the 1847 book had been
printed for private distribution, there was,
as Lucien had supposed, no copyright on
the contents of this edition. Several of the
poems, however, had been included in an
edition published by Macmillan in 1896 and
on this account, Lucien's book constituted
an infringement of their copyright. The
Pissarros were dismayed. They replied on
1 August to say that they had acted in the
belief that the book was public property and
promised to acknowledge Macmillan in the
book. Macmillan offered to give permission
in return for an acknowledgement of their
copyright and a payment of £25. This sum
took account of William Michael Rossetti's
reluctance to allow the Pissarros to publish
poems from the earlier work which he
had omitted from the later edition. Under

protest, the Pissarros agreed to pay as they
could not afford to abandon the book. It was
published towards the end of November
but made a loss on early sales because of
Macmillan's charge.

[A] **Prospectus**

Ashmolean Museum: Pissarro Archive: OA.1687

[B] **Title page**

Private collection

VERSES BY CHRISTINA G. ROSSETTI.
DEDICATED TO HER MOTHER.

Perchè temer degg'io? Son le mie voci
Inesperte, Io so: ma il primo omaggio
D'accettarne la MADRE
Perciò non sdegnerà; ch' anzi assai meglio
Quanto a lei grata io sono
L'umil dirà semplicità del dono.

 Metastasio.

Privately printed at G. Polidori's, No. 15 Park
Village East, Regent's Park, London. 1847.

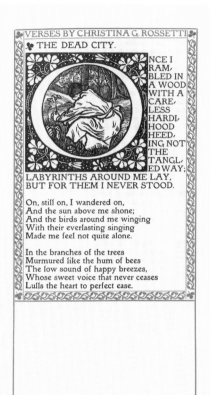

A FEW WORDS TO THE READER.

THE Authoress of these pages was born in 1830, and her first composition, that on her mother's birthday, was written in 1842. These verses have therefore been composed from the age of twelve to sixteen.

As her maternal grandfather, I may be excused for desiring to retain these early spontaneous efforts in a permanent form, and for having silenced the objections urged by her modest diffidence, and persuaded her to allow me to print them for my own gratification, at my own private press; and though I am ready to acknowledge that the wellknown partial affection of a grandparent may perhaps lead me to overrate the merit of her youthful strains, I am still confident that the lovers of poetry will not wholly attribute my judgment to partiality.

G. Polidori.

VERSES BY CHRISTINA G. ROSSETTI

THE DEAD CITY.

ONCE I RAMBLED IN A WOOD WITH A CARELESS HARDIHOOD HEEDING NOT THE TANGLED WAY; LABYRINTHS AROUND ME LAY, BUT FOR THEM I NEVER STOOD.

On, still on, I wandered on,
And the sun above me shone;
And the birds around me winging
With their everlasting singing
Made me feel not quite alone.

In the branches of the trees
Murmured like the hum of bees
The low sound of happy breezes,
Whose sweet voice that never ceases
Lulls the heart to perfect ease.

[c] Advice to the reader and first page

This was the first of the historiated letters which became an attractive feature of Lucien's books from this time onwards.

Ashmolean Museum: Pissarro Archive: 77.4011

[D] Binding

Private collection

ÉTOIT une fois une reine
qui accoucha d'un fils si
laid et si mal fait, qu'on

GRAND seigneur de Grena-
de, possédant des richesses di-
gnes de sa naissance, avoit un

44 RIQUET À LA HOUPPE.

(Deux Versions d'un Conte de ma Mère Loye.) M.DCCCC.VII [1907]

[Charles Perrault: Riquet with the Tuft]

Two historiated initials in four colours designed and engraved by Lucien Pissarro and forty-two initial letters in red designed by Lucien Pissarro and engraved by Esther Pissarro. Small demy 16mo. Colophon and press mark no. 3. Thirty-two leaves. Brook type. 80 copies printed on Arches paper with the Eragny Press watermark of which 75 for sale at twenty-five shillings. Quarter bound in vellum, the title printed on a label upper left with a foliate motif in black, pink and green; boards covered in grey/blue paper. Ten copies on Roman vellum of which eight for sale at four guineas.

Following the ending of the agreement with the Vale Press in 1904, Lucien published no books in French until 1907 when he produced *Riquet à la houppe*. Most of his customers were in Britain or America and, despite his best efforts, there had been little interest in the Eragny Press among French bibliophiles. A series of loss-making publications in 1906, however, encouraged him to think again about making books for the French market. In 1907, he returned to the tales of Perrault, publishing *Riquet à la houppe* in Perrault's version and in a second anonymous version, both in their original French. Because of his recent difficulty in clearing stock, he limited the paper edition to eighty copies.

[A] **First page**

Private collection

[B] **Page 27**

Private collection

GERARD DE NERVAL.

HISTOIRE DE LA REINE DU MATIN & DE SOLI-MAN PRINCE DES GENIES

LES CENT BIBLIOPHILES.

THE ERAGNY PRESS, «THE BROOK», HAMMERSMITH, LONDON, W. M.D.CCCC.IX.

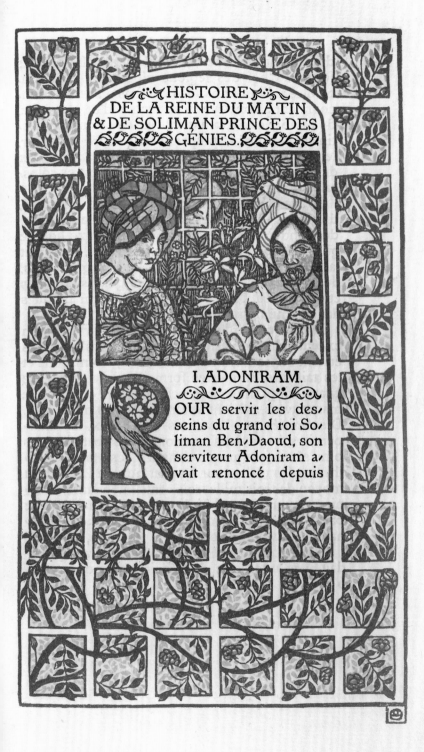

HISTOIRE DE LA REINE DU MATIN & DE SOLIMAN PRINCE DES GÉNIES.

I. ADONIRAM.

POUR servir les desseins du grand roi Soliman Ben-Daoud, son serviteur Adoniram avait renoncé depuis

45 GERARD DE NERVAL.
HISTOIRE DE LA REINE DU MATIN
& DE SOLIMAN PRINCE DES GÉNIES.
LES CENT BIBLIOPHILES. THE
ERAGNY PRESS, « THE BROOK »,
HAMMERSMITH, LONDON, W.
M.D.CCCC.IX [1909]

[Gérard de Nerval: The Story of the
Queen of the Morning and of Soliman,
Prince of the Djinns]

Title page in grey/green, with lettering in gold,
first page illustration and border in five colours,
fourteen illustrations in grey/green, twelve histo-
riated initials in gold and colour, three tailpieces
and onehead piece in grey/green designed by
Lucien Pissarro and engraved by Lucien and
Esther Pissarro. Small demy octavo. Colophon
and press mark no. 3. Eighty-eight leaves. Brook
type. 130 numbered copies printed on specially
commissioned Arches paper with watermarks of
Les Cent Bibliophiles and the Eragny Press. Fully
bound in olive green morocco, the sides stamped
in gold with an all-over pattern of carnations; title
stamped on spine in gold.

In April 1907, Lucien wrote to Esther from
Paris to tell her that he had concluded
an agreement with the Société des Cent
Bibliophiles for an edition of Nerval's
colourful Eastern tale, *Histoire de la reine
du matin*. The Society would pay 10,000
francs (£400) for 125 copies of the book
and, if the outcome was successful, might
consider further commissions. The idea
had been suggested to Eugène Rodrigues,
president of the Society, by Roger Marx, a
prominent figure in the Paris art world, who
promoted the work of the Impressionists
over many years. After years of difficulties,
the commission brought promise of salva-
tion. As recently as 24 October, Lucien had
contemplated closing the press down. His
scheme to sell a book of Herrick's poems by
subscription had failed for want of interest
and sales from stock were poor. Now, with
an advance of 1,500 francs, Lucien began
work on what was to become one of his
finest books. He explained to Rodrigues

that he could not print a large book in
colour on his press but would make a book
similar in format to his Ben Jonson. In
February 1908, he temporarily laid off his
printing assistant, Thomas Taylor, while he
concentrated on engraving the woodblocks.
He explained to Rodrigues that he had
developed a method of combining colour
and gold leaf in printing initial letters
which he intended to use in illuminating
the book. This proved more troublesome
than he had anticipated, as he explained to
Rodrigues in October, when apologising
for the delay in finishing. In February, he
apologised again, pointing out that the
lack of daylight in winter had made colour
printing difficult. At the end of February, he
began to exchange letters with Rodrigues
about the design of the cover. Lucien liked
the idea of a boxed portfolio but Rodrigues
wanted a limp calfskin binding without
cardboard lining, doubled over to provide
solidity. Leighton confirmed that this
could be done and by August, Lucien was
ready to send the pages to the binder. He
was, however, held back by a problem with
the brass stamp for the title, supplied by
Knight and Cotterell, which had to be recut
and which was not ready until September.
Finally, Lucien wrote to Rodrigues on
22 October 1909 to say that he had sent
the books to Paris the previous afternoon.
Despite the generous subsidy, costs had
over-run and Lucien had to ask Rodrigues
for an additional 2,500 francs. This was
approved by the membership. Lucien, in
his defence, pointed out that the twenty
illustrations which he had originally agreed,
had been increased at Rodrigues' suggestion
to thirty-two.

[A] Title and first page

The sumptuous character of the opening
page of *La Reine du matin* is created by
the technical feat of combining five colour
blocks on the main image with type and
an initial, printed separately in blue, pink,
dark green and gold. It was not easy to print

a clean impression with gold leaf which
tended to stick to the damp paper where
it was not wanted and there was much
wastage. The pattern recalls Morris's 'Trellis'
wall-paper. The figures in the title page
are Balkis, Queen of the Morning, and her
nurse, Sarehil, picking flowers by the waters
of Siloe. The bird in the initial is Hud Hud,
a bird of prophecy who indicates to Balkis
that she is destined to marry Adoniram,
Soliman's chief artist and architect.

Private collection.

[B] **Five historiated initials, four illustra-
tions, one headpiece and one tailpiece.**

Gérard de Nerval's *Histoire de la reine du
matin* tells the story of Balkis, Queen of
Sheba, King Soliman and Adoniram, an
architect, master builder and sculptor. The
story first appeared in Nerval's *Voyage en
Orient*, published in 1851, some years after
Nerval had visited the Near East. We
learn from the introduction (omitted in
the Eragny text) that the story is told by a
professional story teller in an Istanbul café.
Although Nerval drew heavily on ancient
Mohammedan and Hebrew sources, his
tale is replete with nineteenth-century
Romantic stereotypes: the artist as hero;
the excesses of genius; doomed love; the
vanity of kings. The story tells how Balkis
comes to Jerusalem to meet Soliman, her
fellow sovereign. Her wit humiliates but also
captivates the king.

1 Letter N

The letter N marks the beginning of the
third chapter which tells how Balkis offends
Soliman by preferring the palace built by
Adoniram, Soliman's chief sculptor and
architect, to the temple designed by himself.
The solitary and misanthropic Adoniram
meets Balkis and falls under her spell.

Ashmolean Museum: Pissarro Archive: 77.1979

2 Letter C

Chapter four which begins with this initial

describes the feast given in honour of
Balkis. Soliman tricks her into agreeing to
marry him.

Ashmolean Museum: Pissarro Archive: 77.1980

3 Tailpiece to Chapter IV

4 Letter A

Adoniram is driven by superhuman ambition to create works of art of a grandeur never seen before. With 30,000 foundry workers, he creates a vast furnace and excavates the plain of Sion to hold the molten bronze. Lucien's initial letter is decorated with a night-time view of the Sea of Bronze.

Ashmolean Museum: Pissarro Archive: 77.1981

5 The Explosion

Three workmen, resentful that Adoniram has not promoted them to a mastery in their craft, sabotage the furnace. The lake overflows and the furnace explodes with great loss of life.

Ashmolean Museum: Pissarro Archive: 77.1927

6 Letter T

Balkis grieving at the destruction caused by the explosion.

Ashmolean Museum: Pissarro Archive: 77.1982

7 The Apparition.

Adoniram, distraught, sees a ghostly figure rising from the flames. The apparition identifies himself as Tubal-Cain, the descendant of Cain and inventor of casting and forging. Tubal-Cain takes Adoniram to the Underworld to meet his ancestors. Adoniram discovers that he is of greater lineage than his master Soliman.

Ashmolean Museum: Pissarro Archive: 77.1915

8 Letter L

Balkis hears that Adoniram has mended his giant furnace and completed his work to the general enthusiasm of the people. They meet again and Adoniram reveals that he is descended from the famous Tubal-Cain. Balkis, prompted by her prophetic hoopoe, Hud Hud, realises that they are destined to be united. They plan to flee from Jerusalem. The chapter beginning with the letter L describes the last meeting of Balkis and Soliman at which Soliman falls into a drunken stupor.

Ashmolean Museum: Pissarro Archive: 77.1987

9 Balkis and the king

Balkis hovers behind the intoxicated Soliman and tells him that she will never marry him. She flees from the city with her retinue.

Ashmolean Museum: Pissarro Archive: 77.1941

10 The last chapter

Adoniram, with reluctant permission from the king, makes arrangements to leave

Jerusalem but is assassinated by the three workmen. Soliman, grieving for Balkis, takes five hundred wives but does not find happiness. He uses magic powers to ensure that his body will be preserved on his throne until the end of time but after two hundred years, one of the columns of the canopy, eaten through by a butterfly, collapses onto the throne and his body is reduced to dust.

Ashmolean Museum: Pissarro Archive: 77.1988

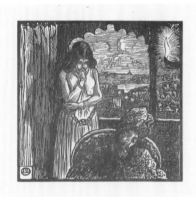

11 Head piece on page 156.

Ashmolean Museum: Pissarro Archive: 77.1989

[c] Binding

Lucien had suggested grey as a colour for the calfskin cover. There was some trouble obtaining the right hue. The book was finally bound in olive green calfskin stamped in gold with an all-over pattern of carnations. This had been first used, albeit in a very different form, for the cover of the second printing of *Areopagitica*.

Ashmolean Museum: Pissarro Archive: 77.4013

[d] Eadburgha binding

Katherine Adams bound a number of books for Lucien at the Eadburgha Bindery in Broadway between 1910 and 1912. She delivered this copy to Lucien in October 1910. Lucien was very pleased with her work. He recommended her to the American bibliophile, Alfred Fowler, in 1912: 'I wonder if you have sent your copy of Soliman to be bound by Miss K. Adams? I had my own copy bound by her, she did it beautifully – she is a delightful artist.'

Private collection.

46 JUDITH GAUTIER DE L'ACADÉMIE GONCOURT. ALBUM DE POEMES TIRES DU LIVRE DE JADE, THE ERAGNY PRESS, THE BROOK, HAMMERSMITH, LONDON, W. M.D.CCCC.XI [1911]

[Collection of Poems from the Book of Jade]

Title page with title and two Chinese characters in gold, eight illustrations in roundels printed in gold and colour, eleven ornaments in colour and one historiated letter in grey, green and gold: all designed by Lucien Pissarro and engraved on wood by Lucien and Esther Pissarro. Crown octavo. Colophon and press mark no. 3. Brook type. Eighteen folded leaves printed on the outer sides in red and grey with sixty-five initials in gold. 130 copies of which 115 numbered copies on Japanese vellum for sale at four pounds, five copies on Japanese vellum reserved for museums and ten numbered copies on Roman vellum for sale at eight guineas. Covers of white kid, green kid spine, stab bound with green silk thread, front cover stamped in gold with the title and a lotus flower ornament upper right.

Once work on *La Reine du matin* had been completed, Roger Marx arranged a commission for a book from Pierre Dauze, president of Le Livre contemporain. While waiting for a text and a clear understanding of the terms, Lucien's thoughts turned to another project. In July 1910, he wrote to Marx asking him to find out if Judith Gautier would give him permission to publish a small selection of poems from her *Livre de jade*. This had originally been published in 1867 with seventy-one poems and reissued in 1902 with forty more. Gautier was delighted and her publisher saw no objection. In September, when Dauze instructed Lucien to begin the illustrations for his book, he set the *Livre de jade* aside to concentrate on engraving blocks for the commissioned work. In January 1911, as the arrangement with Dauze seemed on the point of breaking down, Lucien resumed work on the *Livre de jade* but then turned

back to Dauze's book in early March after reaching an agreement over payment. Work on printing the poems was, meanwhile, continued by Esther and Thomas Taylor. They began in May and finished in October. Lucien was attracted by the oriental theme because he wanted to publish a booklet similar in type to a 'Japanese album'. The leather covers were stab bound with silk thread in the Japanese manner and the pages were printed on one side only as they are in Japanese books. Unlike the Arches paper which Lucien normally used, Japanese vellum did not require to be moistened for printing. Gold leaf, which tended to stick to damp paper, printed well on vellum and vellum quality paper but Lucien generally preferred softer Arches for printing text. The French prospectus which Marx helped to write and to distribute attracted a satisfactory number of subscriptions.

[A] **Frontispiece**

Private collection

L'UNE d'elles voudrait parler, confier à sa compagne, le chagrin secret qui meurtrit son cœur.

ELLE jette un regard anxieux vers les feuillages immobiles, et, à cause d'un perroquet, aux ailes chatoyantes, perché sur une branche voisine, elle soupire, et ne parle pas.

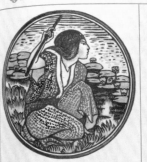

UNE fleur s'ouvre, au-dessus de l'eau profonde... de l'eau profonde...

JE prends une ligne et je la lance, vers cette fleur aux racines profondes...

VERS cette fleur aux racines profondes...

LE mystère des dessous ténébreux est troublé, le repos cesse, l'agitation s'étend au loin.

J'ESSAIE, avec la ligne, de nouer le lotus... comme si c'était, là, son cœur!...

LE soleil flotte à l'extrême bord du ciel; il se dissout, s'éteint, il se noie dans la nuit.

IL se noie dans la nuit!...

JE remonte à l'étage supérieur. Je m'arrête devant ma toilette!...—O le triste et dévasté visage!...

LE triste et dévasté visage!...

LES plantes sauront reverdir et former des pousses nouvelles...

COMMENT, sans espérance, ai-je pu même parvenir jusqu'à ce jour?...

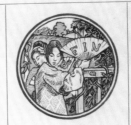

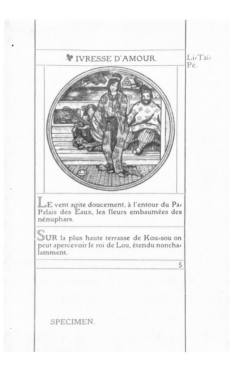

❦ IVRESSE D'AMOUR. Li-Taï-
Pé.

LE vent agite doucement, à l'entour du Pa-
Palais des Eaux, les fleurs embaumées des
nénuphars.

SUR la plus haute terrasse de Kou-sou on
peut apercevoir le roi de Lou, étendu noncha-
lamment.

5

SPECIMEN.

[B] **Pages 22 and 23**

The roundel illustrates *The Red Lotus*, a poem by Ly y Hane: the poet casts a line to catch a lotus whose roots lie in mysterious depths.

Private collection

[C] **Pages 24 and 25**

The book ends with the last verses of *The Red Lotus* in which Ly y Hane regrets the loss of youth's bloom.

Lent by the Bodleian Library

[D] **Specimen page for**
The Ecstasy of Love

The image illustrates a poem by Li-Taï-Pé which describes a dancer performing before a king.

Private collection

[E] **Binding**

Ashmolean Museum: Pissarro
Archive: 77.4019

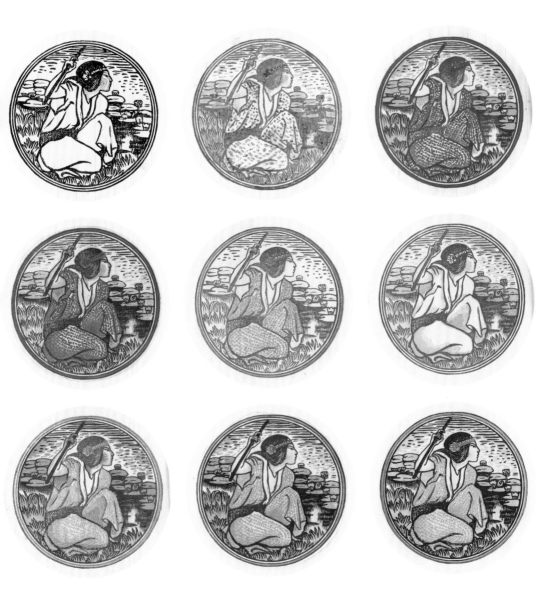

[F] **Study of a girl crouching for**
The Red Lotus

Black and white chalks with blue and pink
watercolour on dark grey paper. 240 × 204mm.

Lucien commonly made large figure studies
from the life once he had worked out an idea
in a preliminary sketch.

Ashmolean Museum: Pissarro Archive: 77.2070

[G] **Nine trial impressions of**
The Red Lotus

One is printed from the line block, corrected
with white body colour; one has been
coloured with watercolour; the remainder
have been printed from the blocks with
different combinations of colour and gold.

Ashmolean Museum: Pissarro Archive:
77.2064–6, 2035–7

[H] Figure study for the girl on the left of *In the Palace*

Black chalk with blue/grey, violet and brown watercolour on pale grey paper.
483 × 311 mm

Ashmolean Museum: Pissarro Archive: 77.2131

[I] Figure study for the girl on the right of *In the Palace*

Black chalk with blue/grey, violet and brown watercolour on pale grey paper
482 × 310 mm

Ashmolean Museum: Pissarro Archive: 77.2061

[J] Trial pages.

1. *My eyes are Fixed*
2. *Springtime Chill*
3. *In the Palace*
4. *The Song of the Birds*
5. *The Emperor*
6. *Tail Piece*

Ashmolean Museum: Pissarro Archive: OA.1674–1680

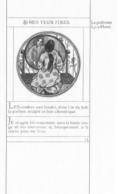

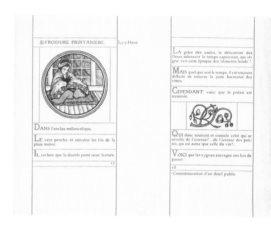

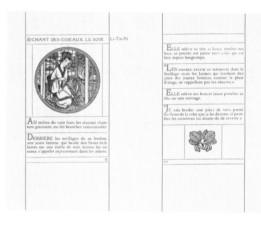

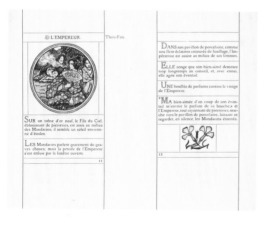

[K] PREFACE by DIANA WHITE
to an ALBUM OF POEMS from the LIVRE
DE JADE. Translated from the Chinese by
JUDITH GAUTIER.

In 1948, Esther reissued Diana White's
preface to the *Livre de jade* in an edition
of sixty copies on Japanese vellum, stab-
bound and printed in the Brook type
without colour. It is perhaps not so much
an Eragny book as a homage to the press
and a farewell to printing at Brook House.
It is curious, as Diana White pointed out
to Esther, that it does not refer to Lucien
who had died four years earlier.

Ashmolean Museum: Pissarro Archive: 77.4015

47 ÉMILE MOSELLY. LA CHARRUE D'ÉRABLE PARIS LE LIVRE CONTEMPORAIN. M.CM.XII [1913]

[The Maple-wood Plough]

Title page with border in grey/green, green and pink, twelve illustrations each printed from four blocks designed by Camille Pissarro and engraved on wood by Lucien Pissarro; one headpiece in black and ten historiated initials, ten head pieces and ten tailpieces printed in black and two colours, designed by Lucien Pissarro and engraved in wood by Lucien and Esther Pissarro. Small demy octavo. Colophon and press mark no. 3. Seventy-six leaves. Brook type. 116 numbered copies printed on specially commissioned Arches paper with watermarks of Le Livre contemporain and the Eragny Press. Fully bound in green morocco; title and apple motif stamped in gold upper right; inside cover stamped in gold with apple motifs and the monogram of Le Livre contemporain.

In February 1904, Lucien told Esther that he was thinking of following the book of Browning's poems with a biography of his father. Two weeks later, at Roger Marx's suggestion, he proposed this to the Société des Amis des Livres in Paris as something which the Society might wish to commission for private distribution. The book would be illustrated with engravings by Lucien after the drawings by Camille for the *Travaux des champs* which Lucien had hoped to publish in his father's lifetime. The proposal came to nothing on account of an agreement which Lucien had with John Lane which guaranteed Lane the right to distribute in America all books printed with the Brook type. As the Society could not supply Lane with copies nor could it supply Lucien with a different type, the plan was dropped. In November 1906, Lucien began negotiations with the Paris dealer, Bernheim jeune, to publish the book. Octave Mirbeau accepted an invitation to write the biography and Gaston Bernheim agreed to act as the Paris agent but, as Bernheim pointed out in a letter of 11 December, he had no intention of contributing to the costs. Lucien turned

to Pierre Dauze, president of a society of bibliophiles, the Société des xx, to ask him if he would commission the book on behalf of the Society. Lane had ended his agreement with Lucien in 1905 and the rights to distribution were no longer a hindrance. This proposal was not taken up and, although discussion with Bernheim continued into the summer of 1907, the project came to nothing. Lucien's affairs did not allow him to proceed without capital or sponsorship and from September 1907 his time was wholly taken up by *La Reine du matin*. In November 1909, having delivered *La Reine du matin* to Rodrigues, he renewed contact with Dauze, now president of Le Livre contemporain, and suggested that his organization might take up the book. Dauze, prompted by Roger Marx, was attracted by the idea. He clearly admired *La Reine du matin* and hoped for something similar. The problem was that Lucien planned to give the new book an entirely different character, low in key and earthy like his father's drawings, and he resisted any suggestion that it should follow the exotic, colourful manner of the *La Reine du matin*. From the start, he intended to print the illustrations *en camaieu* and minimize the ornaments. Dauze felt this might be too severe. Lucien refused to spoil the uniformity of the book by introducing brighter colour but offered to print the ornaments *en camaieu* at the same price as he was expecting for printing in black alone. This was a generous concession as printing *en camaieu* involved three blocks and was as costly and time-consuming as standard colour. At this stage, the idea of a biography had been dropped, leaving Dauze and Lucien not only without a text but also without an author. Lucien suggested that Jules Renard or André Theuriot might be willing to contribute a text. Renard accepted but fell ill and could not do the work. In October 1910, Dauze told Lucien that he had contacted the writer, Emile Moselly, who agreed to supply twelve short chapters on a rural theme matching the twelve drawings by Camille.

montrait l'incendie dévorant sa maison, les murs calcinés et la charpente du toit s'écroulant sur les décombres fumants, dans un tourbillon d'étincelles rouges.

Poussant toujours un hurlement de bête, elle entra dans les ténèbres, dans les ténèbres miséricordieuses......

Son mari, qui revint des champs à la tombée de la nuit, la trouva blottie derrière une futaille de la cave, serrant dans sa main le manche de la baratte. Il fallut quatre hommes pour la lier et la porter sur un chariot qui l'emmena à Braqueville, l'asile départemental d'aliénés.

18

MESSIDOR.

A moisson est terminée. Par les chemins ravinés, les grands chariots, chargés de gerbes à en craquer, sont redescendus vers le village, et ils se sont engouffrés dans les granges, suivis des poules, qui picoraient à la hâte les épis tombés.

Les champs ont perdu la parure opulente des blés, des blés qui avaient poussé dru, où les coquelicots par endroits saignaient, où les nielles s'empourpraient, où les bleuets dressaient leurs têtes fi-

19

par des bois, où l'on entend le jacassement des geais, donnant la chasse aux oisillons. Le vieux, dont l'humeur devient farouche avec l'âge, ne déteste pas les journées de travail qui le ramènent dans cet endroit solitaire, où il peut, loin des bavards et des oisifs, ahanner à son content. Ce dur travail de la terre, il a une douceur dont on ne se rassasie jamais! aussi il s'en donne à pleins bras, seulement visité de temps à autre par la buse, qui plane en décrivant de grands cercles, par les renards chasseurs, qui battent la lisière du bois, en poussant par intervalles un bref glapissement.

Jean Baptiste possède dans ces parages une belle pièce de terre, sur le bord d'un large chemin, qui permet de sortir facilement les récoltes. Elle lui vient de son père, le Nicolas, qui la tenait de son père; jadis on l'aurait bien vendue deux mille francs, maintenant on n'en tirerait pas deux cents, si on la mettait aux enchères. En vain le vieux laboureur voudrait se faire illusion; les pièces voisines de même contenance ne sont pas montées à ce prix. Et cela, avec le départ des enfants qui refusent de travailler la terre, c'est le gros chagrin du vieux, le souci qui empoisonne sa vie et mêle à ses dernières joies une sorte d'amertume.

Une si bonne terre! Par moments, quand la pensée de ce désastre se présente à son esprit, il voudrait se persuader que les hommes n'ont pas tort, que la terre est usée et qu'elle mérite ce dédain. Alors il se baisse; il en ramasse une poignée, qu'il effrite dans ses mains calleuses, et il l'examine longuement, il la fait couler dans ses doigts, il

62

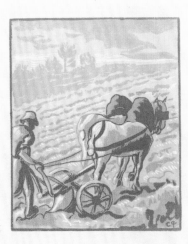

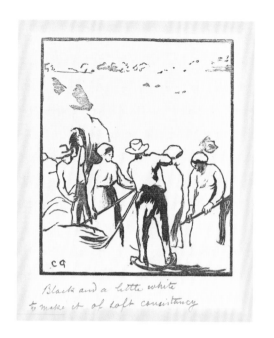

Blacks and a little white to make it of soft consistency

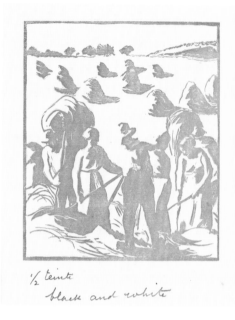

½ teinte black and white

Lucien, by now, was impatient to have a text. He was working on the blocks for the illustrations but could not design the ornaments and initial letters without an idea of the contents. Meanwhile, Lucien and Dauze became embroiled over costs. Lucien had not yet signed a contract with the Society and was anxious to receive a first advance. He would not concede a reduction in the 250 francs which he had asked for each cul-de-lampe, headpiece and ornamental letter. At the beginning of 1911, he complained to Marx and, with Marx's backing, reached an agreement with Dauze in early March. This involved cutting the number of chapters from twelve to ten (while keeping all twelve of the engravings after Camille's drawings) and limiting the number of pages to 120. By this means, Lucien's costs could be kept within the 15,000 francs fixed by Dauze without lowering the charge for each ornament. The text, however, had not yet appeared. In June, Lucien visited Moselly in Rouen and they agreed that Moselly should visit the region of Eragny to get an idea of the landscape in which the illustrations were set. But Moselly fell ill and the text remained unwritten. After promises on one side and recriminations on the other, Lucien received a specimen chapter in late September. He had, while waiting, composed the head pieces for the chapters, basing his designs on the drawings by his father which Moselly was expected to follow. He had also cut some initials so that Moselly had to begin his chapters with words which began with the letters which had been cut. Moselly readily complied but his rate of delivery was slow and the printed text was not sent to the binder until February 1913. On 18 February, as agreed by the terms of the contract, most of the proof impressions, the blocks and all the drawings, including thirteen by Camille, were sent to the treasurer of Le Livre contemporain. The book itself followed in the first week of March. It was, as the secretary of the society confirmed in a letter of 9 March, 'un fort joli livre'.

[A] **Title page** *illustrated on p. 2 of this book*

Private collection

[B] **Pages 18 and 19**

Ashmolean Museum: Pissarro Archive: 77.4016

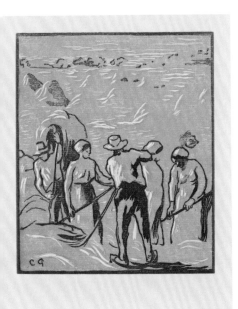

White point of brun rouge, crimson labe and indigo ink —

[c] **Pages 62 and 63**

Private collection

[d] **Four trial impressions for the illustration opposite p. 52**

Three of the prints are inscribed with inking instructions: one is printed in black from the line block; the second is printed from the tone block in grey; the third is printed in lilac for the ground; the fourth is printed from the first and third blocks.

Ashmolean Museum: Pissarro Archive: 77.240, 77.241, 77.234, 77.236

[e] **Trial print**

The final image, printed from the three blocks.

Ashmolean Museum: Pissarro Archive: 77.237

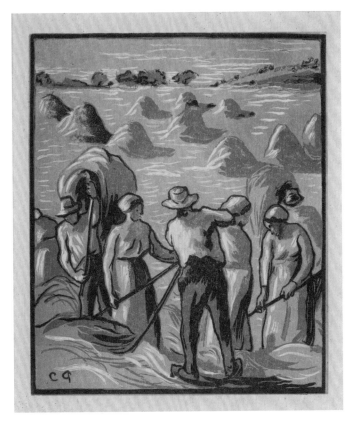

48 WHYM CHOW FLAME OF LOVE
BY MICHAEL FIELD. "LEAVE THE
FIRE ASHES, WHAT SURVIVES IS
GOLD". PRIVATELY PRINTED AT
THE ERAGNY PRESS, THE BROOK,
HAMMERSMITH, LONDON W. M.CM.
XIV. [1914]

Twenty-nine small initials and one large initial
printed in red. Octavo. Colophon and press mark
no. 3. Thirty-six leaves. Brook type. Twenty-seven
copies printed on Arches paper with the Eragny
watermark. Fully bound in red suede, title printed
on a label inset upper right.

In 1906, the authors Katherine Bradley and
Edith Cooper, who wrote jointly under the
name of Michael Field, asked Lucien to
produce a card of remembrance for their
chow. They were pleased with the results
and after Edith Cooper's death in 1913,
Katherine Bradley commissioned a book
of poems dedicated to their dog. An earlier
proposal to commission this had fallen
through because of cost. Bradley was now
seriously ill and constantly pressed Esther
to make haste. The book was designed and
printed entirely by Esther. It was finished
in a small edition of twenty-seven copies in
early May 1914.

Binding

The red cover was chosen by Katherine
Bradley after various suggestions had been
considered. Esther ordered the binding from
Leighton in April 1914

Ashmolean Museum: Pissarro Archive: 77.4017

THE LAST CHAPTER ❧❦

Whym Chow was the last book produced by the Eragny Press. It was not, however, the last projected. On 12 November 1912, Alfred Fowler, a bibliophile from Kansas City, wrote to Lucien to ask if he might consider printing an edition of William Cullen Bryant's *Thanatopsis*, a meditation on death and on the consoling power of Nature. It would be a small edition of twenty copies printed on vellum, perhaps with a frontispiece, with all costs met by Fowler. Lucien replied on 28 November accepting in principle but asking Fowler to have patience. After working on *Le Charrue d'érable* for two years he wanted a period of rest: 'I am so tired of printing that I feel I would not do anything good if I do not stop for a while.' In February, the Pissarros left for Devon and remained there until late April. Once he was back in The Brook, Lucien turned his attention to *Thanatopsis*. On 21 May, he sent Fowler an estimate of forty-five guineas for printing fifty copies on paper and twelve on vellum with a coloured frontispiece and an initial letter in grey and gold. Fowler hoped that the book could be printed from Bryant's original manuscript as this differed from the printed text but, by 15 November, he had been unable to locate a copy. Lucien, meanwhile, was again away from London, concentrating on his painting which was proving more profitable than his books. On 11 December, he wrote to Fowler to let him know that they were thinking of letting The Brook for a year or so and putting the presses into store. Before leaving London, however, Lucien hoped to complete Fowler's little book. The outbreak of war in August 1914, which Lucien later blamed for forcing him to close the press, did not help but it is clear that he had already made up his mind to stop printing for a time. In the spring of 1915 he rented a cottage at Fishpond near Axminster and from then until 1919 he led a nomadic life, choosing picturesque spots in the south of England and painting a great deal. Fowler joined the army and the book was set aside. Fowler was probably not too troubled by this as he had doubts whether he could afford Lucien's estimates. On 1 November 1920, Lucien wrote to tell him that he was about to revive his press, beginning with *Thanatopsis*, but now as a standard publication done at his own expense. Fowler agreed to act as editor in return for one copy of the book. He told Lucien in December that he had found the manuscript in the Library of Congress and sent him a photostat. By the end of March, he had given Lucien the text of the colophon and of the prospectus. Lucien was close to completing the design in 1922 but from this point onwards, nothing more is heard about the book. Painting had taken over his career. He continued to print occasional wood engravings, mostly Christmas cards, but informed his insurance company in July 1927 that printing in The Brook had been discontinued.

BIBLIOGRAPHY

ARCHIVES:

Pissarro Collection: Department of Western Art, Ashmolean Museum, Oxford

OTHER SOURCES:

Bailly-Hertzberg, J., *Correspondance de Camille Pissarro*, 5 vols, Editions du Valhermeil, Paris, 1980–91

Baron, W., *Perfect Moderns. A history of the Camden Town Group*, Ashgate, Hampshire and Vermont, 2000

Beckwith, A., *Illustrating the Good Life: The Pissarros' Eragny Press*, Grolier Club, New York, 2007

Bensusan-Butt, J., *The Eragny Press 1894–1914*, privately printed by the author, Colchester, 1973

Bensusan-Butt, J., *Recollections of Lucien Pissarro in his Seventies*, Compton Press, 1977

Brettell, R., and Lloyd, C., *A Catalogue of the Drawings by Camille Pissarro in the Ashmolean Museum, Oxford*, Clarendon Press, Oxford, 1980

Clément-Janin, 'Peintres-graveurs contemporains: Lucien Pissarro', *Gazette des Beaux-Arts*, 1919, pp. 337–51

Coleman, R., and Seaton, S., *Stamford Brook, An Affectionate Portrait*, Stamford Brook Publications, 1992

Fern, A., *Notes on the Eragny Press*, Cambridge University Press, Cambridge, 1957

Fern, A., *The Wood Engravings of Lucien Pissarro with a Catalogue Raisonné*, 3 vols, thesis, University of Chicago, 1960

Fine Art Society, *Lucien Pissarro 1863–1944*, ex.cat., The Fine Art Society, London, 17 June–11 July, 2003

FitzGerald, F., *The Prints of Lucien Pissarro from 1886 to 1896*, MA thesis, University of East Anglia, 1981

Detail of the binding of *Les Ballades de maistre François Villon* [cat. 22]

Franklin, C., and Turner, J. R., *The Private Presses*, 2nd ed., Scolar Press, Aldershot, 1991

Genz, M. D., *History of the Eragny Press 1894–1914*, Oak Knoll Press and the British Library, London, 2004

Glazebrook, M., *Artists and Architecture of Bedford Park. 1875–1900.*

Gould, B., *The Brook: Chiswick Home of the Eragny Press*, The Private Library second series, vol 4, issue 3, 140–147

Herbert, R. L., Herbert E., 'Artists and anarchism: Unpublished letters of Pissarro, Signac and others – 1', *The Burlington Magazine*, 1960, 1–2, 473–482

Meadmore, W. S., *Lucien Pissarro: Un Coeur Simple*, London, Constable and Co Ltd, 1962

Moore, T. S., *A Brief Account of the Origin of the Eragny Press*, Hammersmith, The Eragny Press, 1903

Perkins, G., *The Gentle Art of Lucien Pissarro*, L'Art Ancien, Zurich, 1974

Pissarro, J., *Quatorze lettres de Julie Pissarro*, L'Arbre, Ferté-Milon, 1981

Pissarro, J., *Camille Pissarro*, New York, 1993

Pissarro, J., and Durand-Ruel Snollaerts, *C. Pissarro. Catalogue critique des peintures*, 3 vols, Wildenstein Institute Publications, 2005

Pissarro, L., *Notes on the Eragny Press, and a Letter to J. B. Manson* (edited with a supplement by Alan Fern), Cambridge, privately printed, 1957

Pratt, B., *Lucien Pissarro in Epping*, Barbara Pratt publications, Loughton, 1982

Rachum, S., *Camille Pissarro's Jewish Identity*, Israel Museum, Jerusalem, 2000

Rewald, J. (ed), *Camille Pissarro, Letters to his Son Lucien*, New York, 1943

Rewald, J., 'Lucien Pissarro: Letters from London 1883–1891', *The Burlington Magazine*, 1949, 91, 188–192

Shikes, R. E. and Harper P., *Pissarro: His Life and Work*, Quartet Books, London, 1980

Stern, D., and Zakai-Kanne, T., *Impressionists to the Present: Camille Pissarro and his Descendants*, ex.cat., Museum of Art, Fort Lawrence, 29 January–30 April, 2000

Thorold, A., 'The Pissarro Collection in the Ashmolean Museum, Oxford', *The Burlington Magazine*, 1978, 120, 642–45

Thorold, A., *Artists, Writers, Politics, Camille Pissarro and his Friends*, ex.cat., Ashmolean Museum, Oxford, 1 November 1980–4 January 1981

Thorold, A., *A Catalogue of the Oil Paintings of Lucien Pissarro*, Athelney Books, London, 1983

Thorold, A., *Lucien Pissarro: His Influence on English Art, 1890–1914*, Canterbury City Council Museum, Canterbury, 1986.

Thorold, A. and Erickson, K., *Camille Pissarro and his Family: The Pissarro Collection in the Ashmolean Museum, Oxford*, Oxford: Ashmolean Museum, 1993

Thorold, A. (ed), *The Letters of Lucien to Camille Pissarro, 1883–1903*, Cambridge University Press, Cambridge, 1993

Urbanelli, L., *The Wood Engravings of Lucien Pissarro and a Bibliographical List of Eragny Books*, Silent Books and the Ashmolean Museum, Oxford, 1994

Urbanelli, L., *The Book Art of Lucien Pissarro, With a Bibliographical List of the Books of the Eragny Press, 1894–1914*, Wakefield, Rhode Island, 1994.